IMAGES
of Rail

The Lackawanna Railroad in Northeastern Pennsylvania

David Crosby

Copyright © 2014 by David Crosby
ISBN 978-1-4671-2168-2

Published by Arcadia Publishing
Charleston, South Carolina

Printed in the United States of America

Library of Congress Control Number: 2013952319

For all general information, please contact Arcadia Publishing:
Telephone 843-853-2070
Fax 843-853-0044
E-mail sales@arcadiapublishing.com
For customer service and orders:
Toll-Free 1-888-313-2665

Visit us on the Internet at www.arcadiapublishing.com

For Bob, Bob, Bernie, and Kip

IMAGES
of Rail

The Lackawanna Railroad in Northeastern Pennsylvania

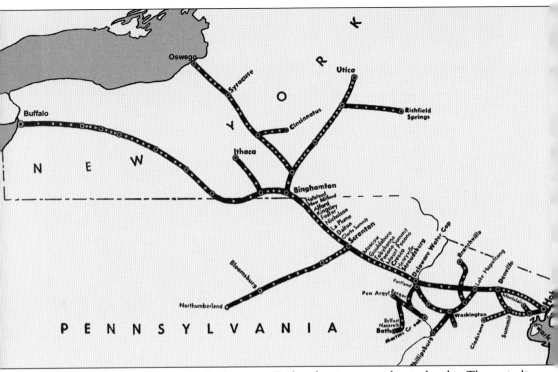

This simplified map shows the Lackawanna Railroad as it appeared in its heyday. The main line connected Hoboken, New Jersey, and Buffalo, New York, and was considered the shortest route between the two cities. Secondary lines such as the Bangor and Portland, Bloomsburg, and Syracuse branches are also shown. Indicating the starting point of the company's growth and expansion, Scranton, Pennsylvania, lies at the center of the system. (Author's collection.)

ON THE COVER: This c. 1907 photograph depicts the 1864 passenger station constructed by the Lackawanna Railroad on the 100 block of Lackawanna Avenue in downtown Scranton. Even as this photograph was taken, the structure was nearing the end of its life span, as the railroad was already constructing a replacement. In 1909, this building would be demolished, supplanted by the newer facility some five blocks to the east. Shortly thereafter, a freight-only station would be constructed in its place. This building would, in turn, be raised during the 1960s and replaced by a state-owned office building. (Watson Bunnell photograph, courtesy of Steamtown National Historic Site.)

Contents

Acknowledgments		6
Introduction		7
1.	Illustrating an Industry	9
2.	Crossing the Delaware	15
3.	The Bangor and Portland Branch	19
4.	Through the Pocono Mountains	25
5.	Scranton	47
6.	The Bloomsburg Branch	79
7.	West to New York	97
8.	The Lackawanna Railroad Today	123

Acknowledgments

The author owes a debt of gratitude to Steamtown National Historic Site for making these images available for publication. Steamtown historian Richard McKnight in particular is to be thanked for his efforts in cataloging the collection of images from which the content of this book was drawn and for assisting the author in locating specific photographs. Prior to their relocation to Scranton, these images had been stored for several decades at the Syracuse University Library, which deserves credit for maintaining the collection. Also appreciated are the efforts of John Willever, Bob Bahrs, and other Lackawanna Railroad historians for their decades-long efforts investigating and organizing the collection.

Except where noted, all photographs in this book were taken by Watson Bunnell and John Anneman while employed by the Lackawanna Railroad and appear courtesy of Steamtown National Historic Site. Whenever possible, the original Lackawanna Railroad image identification numbers have been included for reference.

Introduction

The Delaware, Lackawanna & Western Railroad can trace its roots to the 1832 chartering of the Liggett's Gap Railroad. The railroad was intended to run from the tiny Pennsylvania hamlet of Slocum Hollow (now Scranton) west to the New York state line. Construction would not begin on the Liggett's Gap Railroad until 1850 when the Scranton family invested in the line as a way to transport products from their ironworks in Slocum Hollow to customers in New York. The first products moved by rail from Slocum Hollow were in actuality some of the first iron T rails mass-produced in America. By October 1851, the railroad, now known as the Lackawanna & Western, was operating trains as far west as Great Bend, New York.

In 1853, the Lackawanna & Western Railroad acquired the yet-to-be-constructed Delaware & Cobb's Gap Railroad, which had been chartered to run east from Scranton to the Delaware Water Gap. The combined enterprise was christened the Delaware, Lackawanna & Western Railroad but was widely known as simply "the Lackawanna Railroad." By 1856, the Lackawanna Railroad was operating trains across the Delaware River into New Jersey; that same year, Slocum Hollow adopted the Scranton name. At its zenith, the Lackawanna Railroad's main line would stretch from Hoboken, New Jersey, to Buffalo, New York. Including branch and secondary lines, total trackage neared 1,000 miles.

While the iron industry may have been the initial driving force behind construction of the railroad, the Lackawanna Railroad would enjoy prosperity for nearly 100 years due in large part to the lucrative anthracite coal trade. Anthracite, or hard coal, was considered superior to bituminous or soft coal because it tended to burn longer and hotter with less smoke and soot.

The Lackawanna Railroad took full advantage of anthracite coal's clean-burning reputation and introduced Phoebe Snow, a fictional advertising character, in 1900. "Miss Phoebe," as she was often called, spoke in rhymes extolling the cleanliness of Lackawanna Railroad passenger trains, whose locomotives burned the same hard coal. The Lackawanna Railroad also adopted the nickname "the Road of Anthracite."

Prior to antitrust laws, many of the coal mines that fed the Lackawanna Railroad were also controlled by the company. The mining, processing, and transporting of hard coal was such a driving force in the economy of northeast Pennsylvania that Scranton came to be known as "the Anthracite Capitol of the World." Over a 150-year period, beginning in 1820, an estimated three billion tons of coal were mined in northeastern Pennsylvania. During the peak years of anthracite production, over half of the working males in the Lackawanna Valley surrounding Scranton were employed by the coal industry.

Although coal could be considered the Lackawanna Railroad's stock in trade, the company found success in the transportation of other commodities as well. The Lackawanna Railroad would transport large quantities of milk and agricultural products from rural farmlands to larger urban areas. Raw materials for the manufacturing and textile industries as well as finished products from the same would be shipped by rail. The lumber and cement fueled the nation's construction boom of the late 1800s and provided a significant revenue source for the Lackawanna.

In the early 1900s, and buoyed by this financial success, Lackawanna Railroad president William Truesdale set the company on a program of unprecedented modernization. Perhaps the most impressive facet of the reconstruction was the 28.45-mile Lackawanna Cutoff, a section of main line trackage in northern New Jersey. The cutoff utilized millions of tons of fill in conjunction with deep rock cuts in order to reduce grades and eliminate sharp curves. This allowed for higher train speeds and a reduction in operating costs. Other highlights of the new route included the Paulinskill Viaduct and the Delaware River Bridge, two concrete viaducts considered engineering marvels for their time. When completed in December 1911, the cutoff was over 11 miles shorter than its predecessor.

A second, no less impressive, shortcut was constructed through northeast Pennsylvania between Clarks Summit and Hallstead. Upon its 1915 completion, the Clarks Summit–Hallstead Cutoff reduced grades and tight curvature over some 39 miles, reducing total track length by over 3.5 miles. This section of upgraded right-of-way also featured two impressive bridges, the Martins Creek and Tunkhannock Viaducts—the latter remains the largest concrete viaduct in the world to this day.

In addition to the new stretches of track in New Jersey and Pennsylvania, the Lackawanna Railroad built a series of awe-inspiring stations, the grandest of which was located in Scranton, Pennsylvania, and served as headquarters for the company's Scranton Division. The company also expanded its repair shops in Kingsland, New Jersey, in 1903 and Scranton in 1909.

In the years following World War II, the nation would begin shifting away from the use of coal for home heating and other purposes. The decline in coal traffic coupled with competition from trucks using the new interstate highway system marked an end to the years of prosperity enjoyed by the Lackawanna Railroad. Improved inland waterways and ports also proved to be a drain on freight traffic. Even as the company introduced new streamlined passenger trains, Americans abandoned rail traffic for the comfort and convenience of the automobile. The final blow came in August 1955 when flooding from Hurricane Diane destroyed 17 bridges and nearly 60 miles of track.

On October 17, 1960, the Lackawanna Railroad completed a years-in-the-making merger with the Erie Railroad. Known as the Erie-Lackawanna, the resulting company would struggle financially for another 16 years. Some duplication of routes after the merger led to the abandonment of sizeable amount of former Lackawanna trackage in western New York State. On April 1, 1976, the Erie-Lackawanna was folded into the government-created Conrail along with several other faltering Northeast railroads. In the ensuing years, much of the former Lackawanna Railroad would be conveyed to other owners or abandoned outright. In 1980, the Binghamton-to-Scranton section was sold by Conrail to the Delaware & Hudson Railroad and is now owned by that company's successor, Canadian Pacific Railway. Conrail discontinued operations east of Scranton to the Delaware Water Gap altogether that same year. Though dormant for a number of years, the Scranton–to–Delaware Water Gap section of the former Lackawanna has been resurrected and, once again, sees daily freight service.

In October 1984, Conrail would operate its last train over the famed Lackawanna Cutoff in New Jersey. In an effort to stifle the possibility of any future competition, Conrail would remove 27 miles of track from the cutoff, subsequently selling the land to a private developer. Commuter trains now operated by New Jersey Transit continue to utilize the remaining former Lackawanna trackage between Hoboken and Hackettstown in northern New Jersey.

Because the cutoff route was long eyed as a commuter rail link between through northern New Jersey, the state moved to acquire the moribund 27-mile section of right-of-way, completing the purchase in 2001. As of this writing, New Jersey Transit is currently relaying a seven-mile section track west to Andover as long-held plans to reactivate the cutoff inch forward.

One

ILLUSTRATING AN INDUSTRY

If a picture is truly worth a thousand words, then the archive at Steamtown National Historic Site holds nearly limitless volumes of information for students of Lackawanna Railroad history. Perhaps the most significant component of the collection are the roughly 20,000 glass-plate negatives taken by photographers employed by the Lackawanna Railroad at the dawn of the 20th century.

During this period, the Lackawanna Railroad was enjoying a period of prosperity and modernization. Existing rail lines were being rerouted, new facilities were being constructed, and the Lackawanna saw fit to photograph nearly all of it. At the same time, the company also documented a variety of commonplace subjects for more mundane reasons. In one instance, a company photographer might find himself assigned to record damage to company assets from a storm or, in another assignment, photographing his employer's property for pending legal proceedings. In any case, the resulting collection of images provides a fascinating look at an American railroad at the height of its prosperity.

The majority of images in this book were taken by Watson "Bill" Bunnell between 1905 and 1918, although his work for the Lackawanna Railroad stretches into the early 1940s. Bunnell performed work for the Lackawanna as an employee until 1919 and decades after as an independent photographer. John Anneman began working for Bunnell as an assistant in 1912 and later on his own. Thanks to their work, the Lackawanna Railroad in northeast Pennsylvania is well documented.

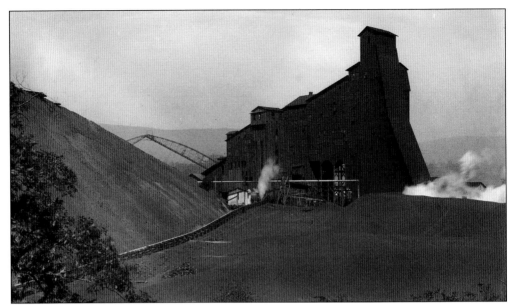

Watson Bunnell began his work for the Lackawanna Railroad's coal department in 1905, and his earliest photographs thus depict the company's coal mining and processing facilities. This September 1905 image shows the Hampton Colliery in Scranton. Collieries consisted of a series of buildings used for the cleaning, processing, and shipment of coal. The large building in the center of this image was known as a breaker. As its name implied, equipment in the building broke coal into various sizes as needed for different uses. (Image A254, Watson Bunnell.)

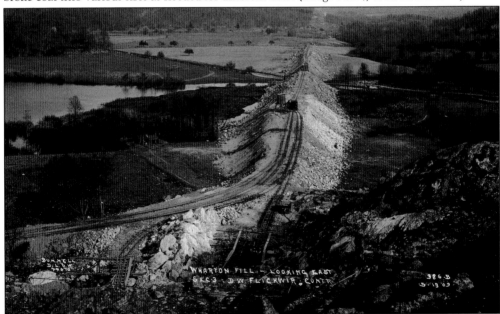

The Lackawanna Railroad would document nearly every phase of its modernization efforts during the first and second decades of the 20th century. This stunning image of the Wharton Fill, dated May 1909, shows the enormity of the New Jersey Cutoff project, with the new main line stretching to the east, away from the photographer. The tracks carving sharply to the left are a temporary means of delivering fill material to the worksite. (Image B386, Watson Bunnell.)

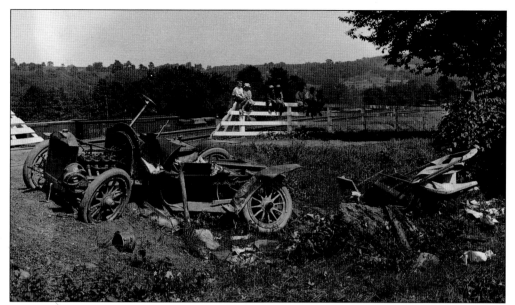

Not every company photograph documents a monumental construction project or significant structure. In this August 1907 image, photographer Bunnell had been dispatched to document the results of an early collision between a train and automobile at an unidentified location, possibly on the Bangor and Portland branch. (Image C95, Watson Bunnell.)

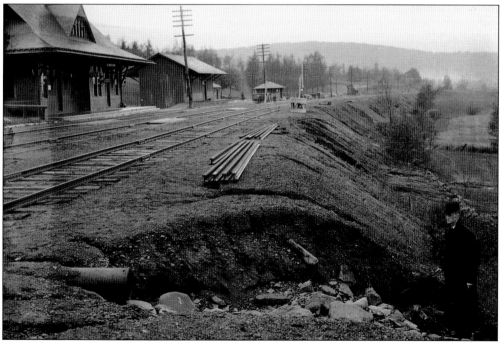

In another example of an average assignment, the photographer illustrates damage caused by excessive water flow from a drainage pipe near the Elmhurst, Pennsylvania, train station. This is an instance where an originally mundane image now provides a fascinating look at buildings that were demolished at least 50 years before this writing. The location of this image from May 1909 is virtually unrecognizable today. (Image C428, Watson Bunnell.)

By its very nature, the railroad could be a dangerous working environment. Potential hazards to employees were often documented, and in some cases, these images were used as an educational tool in an effort to reduce on-the-job injuries. In this July 1915 photograph, an employee uses a ruler to illustrate an area of close clearance between a locomotive and adjacent structure in the Lackawanna Railroad's City Yard in Scranton. (Image C2790, Watson Bunnell.)

Railroad crossings were a constant source of peril for the public and railroad employees alike—so much so, the Lackawanna sought to do away with as many of them as possible. Others that could not be eliminated were often reviewed for potential improvement. This September 1915 image depicts the potentially obscured view of oncoming trains at Courtland Street in East Stroudsburg. Survey equipment at the scene seems to indicate that safety improvements may be in the works. (Image C2935, Watson Bunnell.)

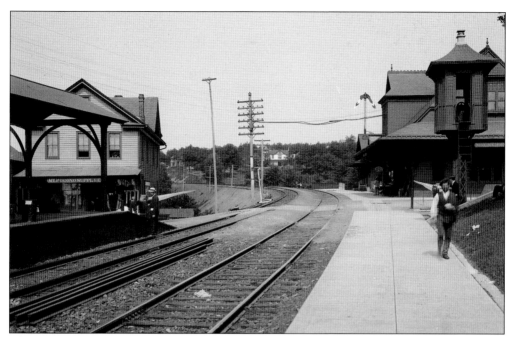

The Lackawanna Railroad was one of the earliest railroads to us concrete in its building projects. This June 1909 image shows a recently completed concrete sidewalk at the Mount Pocono train station. Mount Pocono was a heavily used station, particularly during the summer, as vacationers traveling to the Pocono Mountains would often detrain here. (Image C449, Watson Bunnell.)

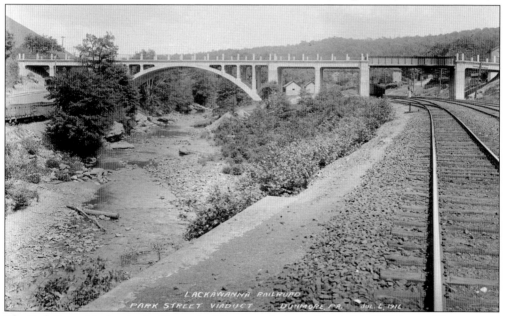

The Park Street Viaduct in the Borough of Dunmore is shown in this July 1916 image. The concrete viaduct was one of several in the area constructed to carry vehicular traffic over the Lackawanna. Visible to the left of this image are cars belonging to the Erie Railroad, which operated a large yard and car repair shop behind the photographer on the opposite side of Roaring Brook. (Image B2397, Watson Bunnell.)

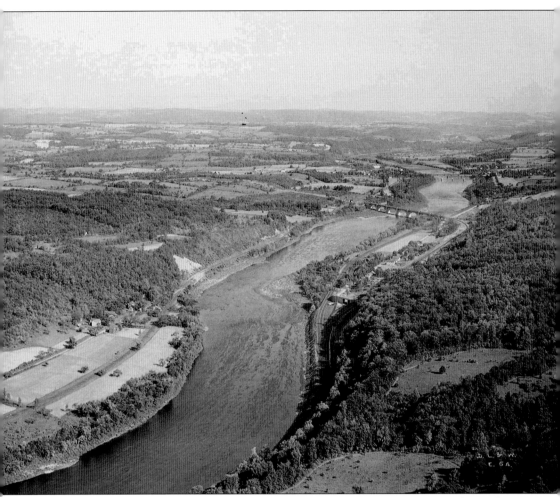

This c. 1911 east-facing view shows the recently completed viaduct carrying the Lackawanna Railroad's main line across the Delaware River from New Jersey into Pennsylvania at Slateford. On the New Jersey side of the river to the upper left are tracks belonging to the New York, Susquehanna & Western Railway. In the upper right of the image is the former main line stretching southward to Portland while the new main line curves toward the foreground as it continues west to Scranton. Near the center of the image is a locomotive turntable and small yard. (Image E64.)

Two

CROSSING THE DELAWARE

The Lackawanna Railroad's crossing of the Delaware River serves as the starting point for this book's in-depth look at the company's presence in northeastern Pennsylvania. This location proved to be a geographical challenge to those engineers designing—and later rerouting—the main line between Pennsylvania and New Jersey.

As the main line approaches the Delaware River from New Jersey from the east, the terrain is relatively flat, allowing for a straight right-of-way. On the west side of the river, however, the topography changes dramatically as mountains rise almost immediately along the shoreline. This necessitated a severe curve upon entering Pennsylvania as the railroad turned almost due north for a short distance as it followed the riverbank through the Delaware Water Gap.

The first trestles built by the Lackawanna to cross the Delaware were constructed of wood and, later, steel. In 1908, the Lackawanna began construction of a new concrete viaduct approximately one mile north of the older bridge site as part of its ongoing modernization program. Opened in 1911, this 1,452-foot span and its connecting track alignment allowed trains to speed through the area at 50 miles per hour.

The viaduct was last used by a special Amtrak train in 1979 that was run as part of efforts to reinstitute passenger service between Scranton and Hoboken, New Jersey. At the time of this writing, nearly 35 years after that last train, the bridge remains dormant.

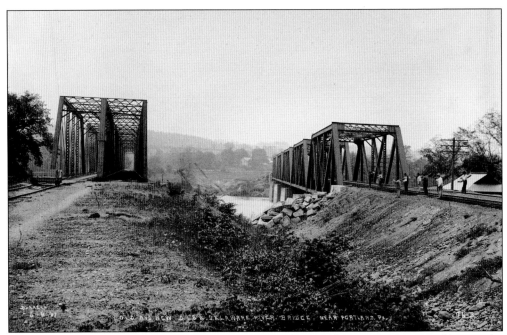

Prior to the 1911 opening of the Delaware River Viaduct, Lackawanna trains would cross the waterway on a conventional trestle. A series of bridges were constructed at this location over the years, the last of which was completed before this June 1907 photograph. On the right is the new bridge, which is wider than its predecessor on the left. (Image B76, Watson Bunnell.)

Construction of the new viaduct has begun in this May 1909 photograph. One of the most challenging conditions at this site was the presence of the original Lackawanna main line, as the new span would pass over the existing right-of-way. The wooden tower and associated cables seen here allowed construction materials to be moved about without interfering with the passage of trains below. (Image 374B, Watson Bunnell.)

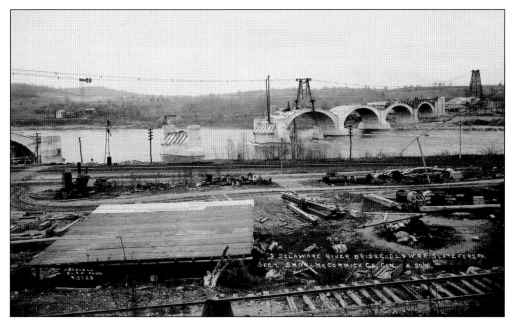

The concrete spans are beginning to take shape in this April 1910 photograph. The photographer is poised on a hillside looking east across the Delaware River toward New Jersey. The original main line is still in operation as it crosses through the center if the image. Once again, wooden towers and cables are in place to ferry construction materials across the tracks and the river. (Image B527, Watson Bunnell.)

The west end of the new viaduct is less than a year old and has already seen one of its arches coated with soot from passing trains. In this image from April 1910, the view looks south toward the town of Portland and the concrete approach angles northward toward the photographer. (Image B576, Watson Bunnell.)

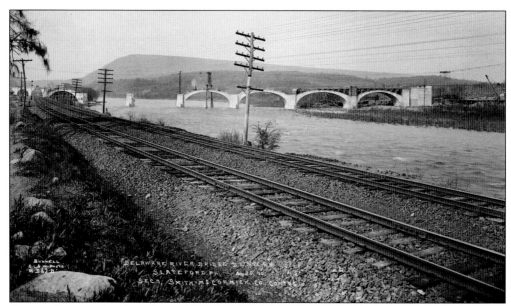

A partially completed viaduct makes for an impressive sight in this north-facing view from April 20, 1910. The tracks in the foreground carry the original main line south to an existing steel bridge in the town of Portland. After the opening of the new viaduct on December 24, 1911, the original right-of-way would be commonly referred to as the "old road." The stretch of track would see continued use, connecting the new main line with the Lackawanna Railroad's Bangor and Portland branch. (Image B569, Watson Bunnell.)

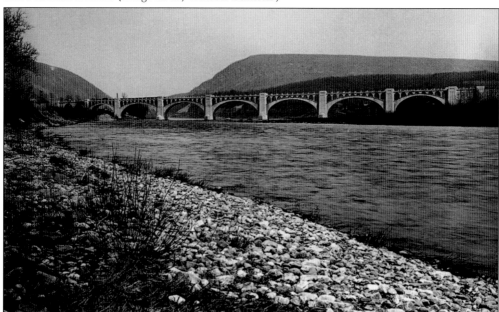

This undated photograph depicts the Delaware River Viaduct after its completion, as viewed from the west shore of the river. The bridge would see continuous use until 1979, when through traffic over this route ceased. The bridge remains dormant as of this date while efforts to return passenger service to northeastern Pennsylvania are still on the drawing table. (Image D211, Watson Bunnell.)

Three

THE BANGOR AND PORTLAND BRANCH

The Bangor and Portland branch of the Lackawanna began as an independently owned enterprise known as the Bangor & Portland Railway. Operations began in 1880 and would eventually connect several Pennsylvania towns, including Bangor, Pen Argyl, Bath, and Martins Creek.

In 1903, the Lackawanna Railroad would purchase the line largely for access to slate quarries and the burgeoning cement industry served by the company. This purchase came during the planning phase of the New Jersey and Pennsylvania Cutoffs and would yield a steady supply of materials during the construction phase of those projects.

With the acquisition of the Bangor & Portland, the Lackawanna also gained a connection with several other lines, including the Pennsylvania and the Lehigh & New England Railroads. A substantial amount of general freight traffic, as well as a brisk passenger business, made this branch profitable for several decades after its purchase. Much of the former Bangor and Portland branch continues to be used by successor companies such as Norfolk Southern.

There is quite a bit of activity taking place around the Lackawanna Railroad's Portland station in this October 1909 view. One group of workers appears to be leveling a gravel walkway between tracks while another is focused on a joint connecting two lengths of rail adjacent to the wooden platform. As evidenced by the string of boxcars at the far end of the building, the structure served as a combination freight and passenger depot. Like many Lackawanna stations in Pennsylvania, the building avoided demolition and is now privately owned. (Image C536, Watson Bunnell.)

A group of local youths poses for the photographer at a grade crossing near the Portland station on October 29, 1909. Beyond the crossing is a covered bridge that carried traffic between Portland and New Jersey. Note the wooden shanty next to the crossing gates. In the days before automation, crossing gates were activated manually by a railroad employee for each passing train. (Image C539, Watson Bunnell.)

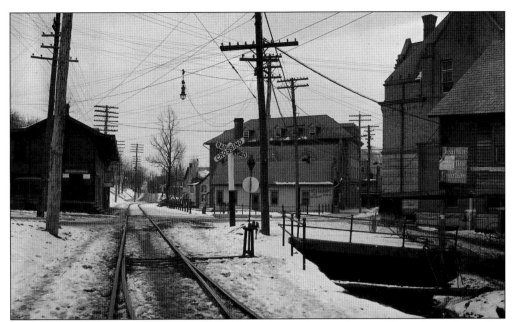

December 15, 1910, appears to be quite chilly in Bangor, Pennsylvania. The nation's love affair with electricity is in full swing, as the photographer captures the Lackawanna Railroad's two-story wooden station surrounded by overhead wires. The character of downtown Bangor has changed significantly over the ensuing decades, and while the rails are still in place, the station no longer stands. (Image C813, Watson Bunnell.)

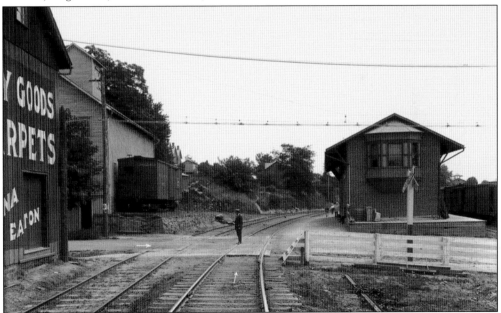

The town of Nazareth, Pennsylvania, is depicted in this June 1908 photograph at South Main Street. In the view looking north, the Lackawanna's brick freight station is to the right. In an interesting turn of events, this section of the Bangor and Portland branch was dismantled long ago, yet the station stands to this day, waiting for trains that will never arrive. Note the white arrows etched into the image, indicating poor visibility for both trains and cross traffic. (Image C258, Watson Bunnell.)

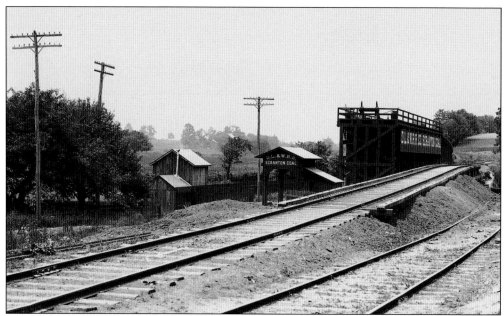

The Lackawanna Railroad's coal dock in Nazareth proudly advertises "Scranton Coal" in this image from June 1908. Loaded railroad cars would be pushed up a ramp on the opposite end of the large wooden structure and their loads of coal would be dumped into the wooden hoppers below. Customers could then pull their wagons to the base of the hoppers for loading. (Image C254, Watson Bunnell.)

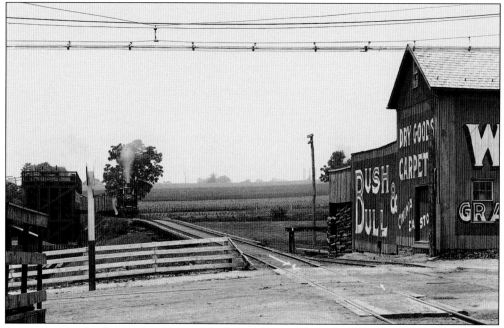

A Lackawanna freight train approaches the Nazareth coal depot from the south on June 20, 1908. As customers turned away from coal as their primary source of home heating in the years after World War II, small retail outlets began to disappear. Today, this site along South Main Street is barely recognizable, with an athletic field having replaced farmland. (Image C256, Watson Bunnell.)

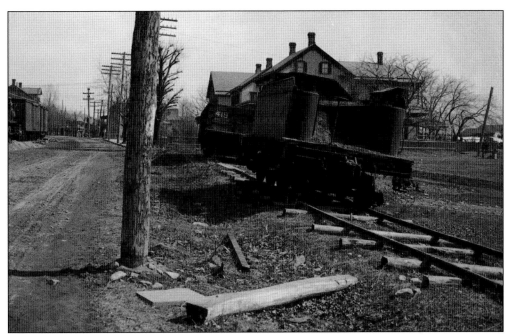

The results of an apparent derailment brought photographer Bunnell to Pen Argyl in March 1911. On the right side of the photograph are what appear to be wreck-damaged cars, including a locomotive tender. In order to clear the main line, the damaged cars appear to have been placed on hastily constructed temporary tracks near the depot. (Image C867, Watson Bunnell.)

The combination passenger station and stationmaster residence is seen to the left of this image. At one time, it was not uncommon for a stationmaster and his family to maintain private living quarters within a passenger station. This March 1911 image is one of very few photographs taken of the structure, which was built in 1888 by the Bangor & Portland Railway. While Bangor & Portland continued south of Pen Argyl to Bath, Pennsylvania, this was the last passenger station of any size on the line. Only a small shelter awaited passengers in Bath. (Image C864, Watson Bunnell.)

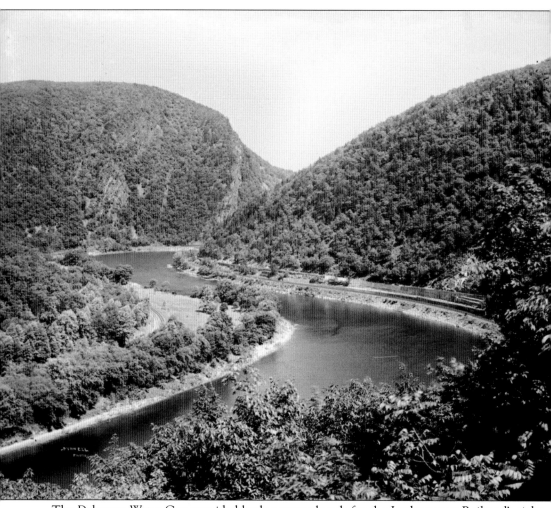

The Delaware Water Gap provided both a natural path for the Lackawanna Railroad's right-of-way and a destination for the company to promote. In this undated image, Watson Bunnell captures the grandeur of this natural wonder. To the west, or right-hand side of the Delaware River, is the main line of the Lackawanna, while tracks belonging to the New York, Susquehanna & Western Railway occupy the eastern riverbank. Today, Interstate 84 occupies the former New York, Susquehanna & Western right-of-way, while the Lackawanna tracks are still in use. (Image E65, Watson Bunnell.)

Four
Through the Pocono Mountains

The Pocono Mountains proved both a blessing and a curse for the Lackawanna Railroad. The breathtaking scenery offered by the peaks and valleys made for a tantalizing and not-so-far-away retreat for those living the congested areas surrounding New York City. Tranquil lakes and picturesque waterways drew vacationers and sportsmen in droves, nearly all of whom rode the train to their destinations. These same lakes provided ice during the winter that would be stored and used throughout the year as a source of refrigeration in railroad cars carrying perishable items to market. By the waning years of the 19th century, a number of grand hotels and resorts dotted the route between the Delaware Water Gap and Mount Pocono.

The same landscape that drew acclaim from its visitors also posed a significant challenge to those whose business it was to keep the railroad operating. Crossing the Poconos necessitated steep grades and a twisting, turning right-of-way, forcing the Lackawanna to dedicate a tremendous amount of resources just to keep trains moving over the mountains. Inclines approached two percent—a two-foot rise in elevation for every one hundred feet forward—on both the east and west sides of the mountain range. In several instances, the terrain mandated a serpentine right-of-way where tracks would double back on themselves through a series of horseshoe curves. All of this accelerated wear and tear on track and equipment. Trains often required the addition of helper locomotives to keep them moving.

In spite of these obstacles, trains continue to traverse the Pocono Mountains to this day. Essentially abandoned and nearly dismantled in the 1980s, this line now sees daily use once again. Freight trains operated by the Delaware–Lackawanna Railroad maintain service between Scranton and the Delaware Water Gap. Passenger trains operated by Steamtown National Historic Site make their way to a number of restored stations along the line as well.

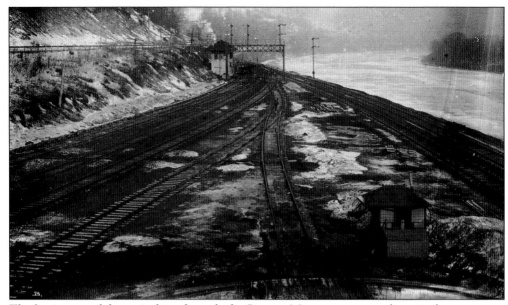

The beginning of the main line through the Pocono Mountains is seen here in this icy scene. Although undated, this photograph was likely taken around the time of the opening of the Delaware River Bridge in 1915. Tracks heading west to Scranton from the bridge are on the left side of the image, while the old main line is to the right. In the immediate foreground is a locomotive turntable, used to rotate many of the helper locomotives used over this section of the Lackawanna. (Image C4493, Watson Bunnell.)

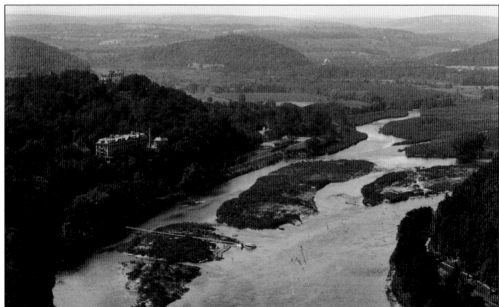

This stunning c. 1915 view of the Delaware Water Gap reveals a vacationer's paradise. In the center of the image is the majestic Kittatinny House overlooking the Delaware River; nearby are the Lackawanna Railroad's passenger and freight stations. On the hilltop sits the equally palatial Water Gap House. Today, Interstate 80 crosses the Delaware at this location, and unfortunately, the hotels are but a memory. (Image E67, Watson Bunnell.)

A row of ornate buildings faces the Delaware Water Gap station, the largest of which is the Delaware House, owned by John Yarrick. Water Gap, as it was simply called by the Lackawanna, was the first of many potential destinations for vacationers traveling by train, and the Delaware House was the closest inn to the railroad here. Although undated, it is believed this image was captured by photographer Bunnell early in his service to the railroad, quite possibly during 1905. (Image A171, Watson Bunnell.)

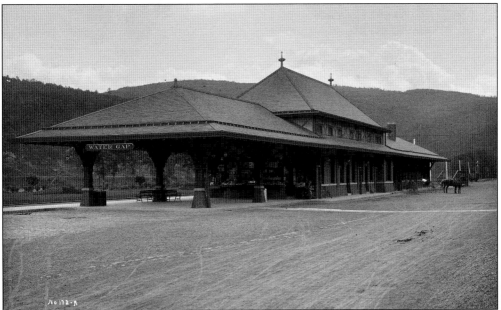

The station at Water Gap was actually a combination of two separate structures sharing a combined concrete platform and slate roof. The passenger facilities are closest to the photographer, while the freight house is at the opposite end. The station was opened in 1903 and last used in the early 1950s. It was sold to the Borough of Delaware Water Gap in 1958 and is now the focus of restoration efforts. (Image A172, Watson Bunnell.)

In 1864, the Lackawanna Railroad constructed a fairly substantial wooden passenger station in the town of Dansbury, Pennsylvania. Rechristened East Stroudsburg in 1870, the stop on the Lackawanna was known simply as "Stroudsburg" and is seen in this east-facing view from March 9, 1909. The building was sold after the demise of passenger service on the line in the 1960s and was home to a restaurant until damaged by fire in 2009. The nonprofit East Stroudsburg Community Alliance subsequently acquired the depot, moved it across the tracks, and is now restoring the building to near original condition. (Image C177, Watson Bunnell.)

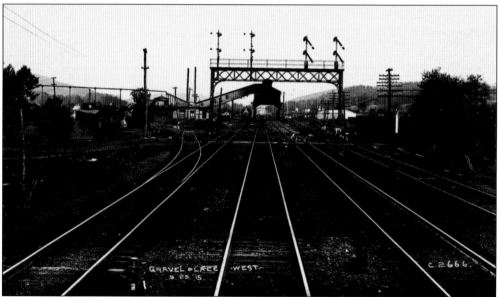

This west-facing view from May 1915 shows the yard and engine-servicing facilities at Gravel Place, just west of East Stroudsburg. The facilities here included a roundhouse and turntable, as well as a concrete coaling tower constructed above the right-of-way, as seen in the center of this image. Having a servicing area here was essential in keeping the many helper locomotives prepared to assist heavy trains on the steep grades to the west of this location. The yard was heavily damaged by floodwaters as a result of Hurricane Diane in 1955. (Image C2666, Watson Bunnell.)

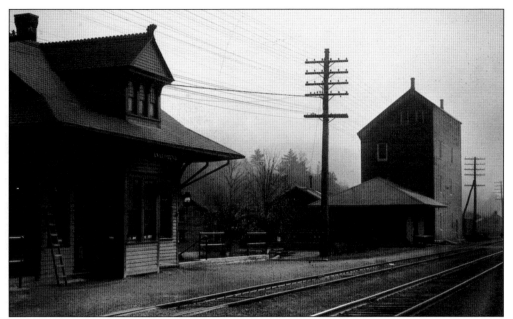

Just west of Gravel Place was the passenger station at Analomink—formerly known as Spragueville—pictured here in October 1914. Much of the patronage of the Analomink station consisted of seasonal visitors on pleasure trips. Although not visible in this image, located adjacent to the station was the Hotel Rapids, a large wooden inn. By the late 1930s, passenger trains no longer stopped here, and the station was demolished sometime later. (Image C2325, Watson Bunnell.)

Approximately three miles west of Analomink, the Lackawanna Railroad crossed Paradise Creek and a primitive wagon road on this steel trestle. Eventually, this bridge would be replaced by fill with both the road and waterway passing under the new right-of-way through a dual-tunnel arrangement. The wagon road would eventually become route Pennsylvania Route 191, which still passes under the railroad at this location. (Image B10, Watson Bunnell.)

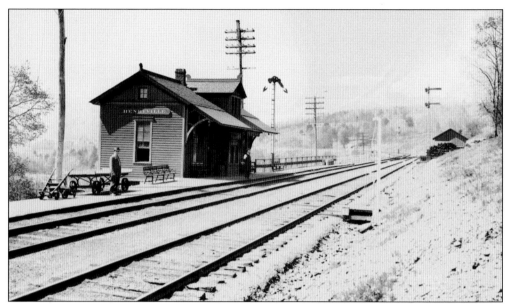

The simple wooden passenger station at Henryville was located well into the Pocono Mountain grade, being situated nearly 250 feet higher in elevation than the previous station at Analomink, some five miles to the west. Like Analomink, Henryville was often used by leisure travelers and sportsmen who took advantage of the excellent fishing in the nearby Paradise Stream. The station at Henryville continued to see use until at least 1954 and was razed sometime after that date. (Image C240, Watson Bunnell.)

The Henryville depot was typical of the small stations along the route between the Delaware Water Gap and Scranton. In this 1908 view taken from the station platform, an eastbound freight slowly climbs up grade as a speeding passenger train comes to into view. Near the end of the platform are several milk cans, which are likely to have been set off for refilling. (Image C241, Watson Bunnell.)

Cresco, Pennsylvania, was the next station along the Lackawanna Railroad's westward climb through the Poconos, roughly five miles west of Henryville and another 400 feet in elevation. In this image from July 1916, a seemingly endless station platform stretches to the east, evidence of the destination's popularity. (Image C3599, John Anneman.)

Built in the mid-1880s, the Cresco passenger station was joined by a freight house in 1902. To the right was a spur that led to nearby Mountainhome. The station closed in 1967, and the adjoining freight house was subsequently demolished. Fortunately, the passenger station was saved and is now home to the Barrett Township Historical Society. (Image C4054, Watson Bunnell.)

The west portal of the "Paradise Tunnel" is seen around 1900. The tunnel, so named for its proximity to Paradise Township would soon be excavated, or "daylighted," and later bypassed altogether to allow the passage of increasingly higher and wider railroad cars. (Author's collection.)

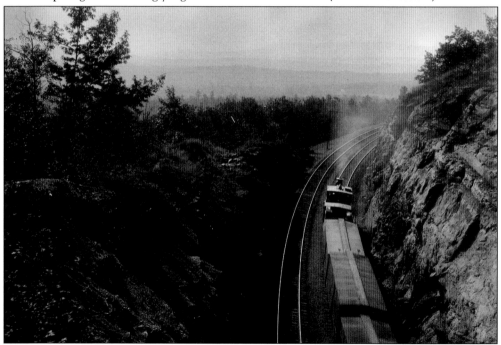

From atop the west portal of the Paradise Tunnel, the photographer is greeted by a sweeping panorama from which one could view the Delaware Water Gap on a clear day. The relocated main line of today skirts the tunnel to the left of this image. Years of untamed tree growth now obscures most of this scene. (Author's collection.)

The Lackawanna Railroad's steep, undulating climb through the Pocono Mountains described throughout this book is well illustrated by this May 1915 photograph. In this view looking west toward the so-called Paradise Curve, the railroad has climbed nearly 1,200 feet over the course of some 25 miles since crossing the Delaware River. (Image 2665, Watson Bunnell.)

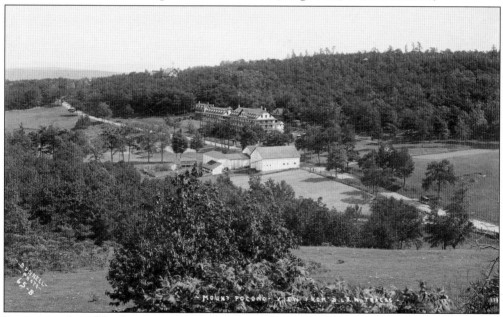

Passengers aboard Lackawanna trains were treated to several breathtaking views during their trips through the mountains. Witness this spectacular view of the Pocono Mountain House near the town of Mount Pocono as viewed from the railroad. The resort buildings seen here dated to the 1870s and were in operation until 1933. Several of the wooden structures avoided demolition until the early 1970s before succumbing to fire. (Image B65, Watson Bunnell.)

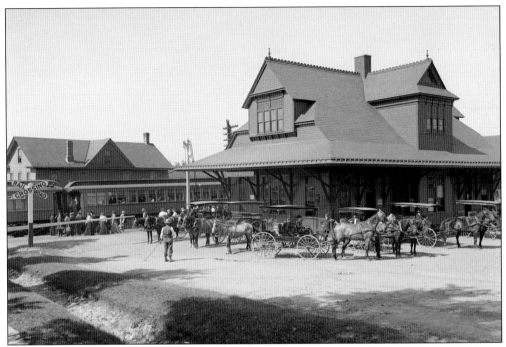

Well-dressed men and women congregate around a passenger train at Mount Pocono in this c. 1900 photograph. As the large gathering of surreys indicates, this station served throngs of arriving vacationers upon its completion around 1886. (Author's collection.)

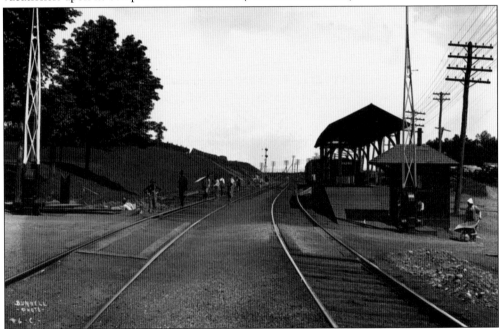

Laborers work to construct additional platform space at the Mount Pocono station in June 1906. Unlike the other platforms in this scene, however, this new pathway is to be constructed of concrete instead of wood. The Lackawanna utilized concrete not only in bridge construction, but also in stations, interlocking towers, and walkways. (Image C6, Watson Bunnell.)

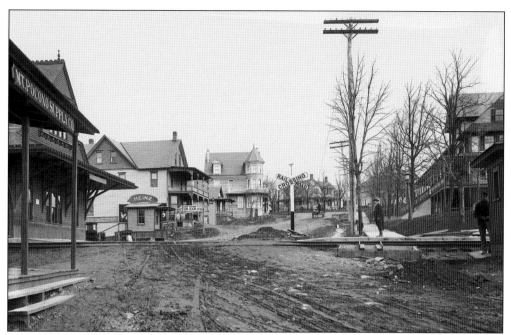

The village of Mount Pocono is viewed from the south side of the railroad on April 9, 1908. A new innovation, indeed a novelty at the time, was the automotive business on the opposite side of the tracks. Advertising "Automobiles to Ride," the Mount Pocono Motor Car Company offered automobile rentals to passengers detraining at this location. (Image C216, Watson Bunnell.)

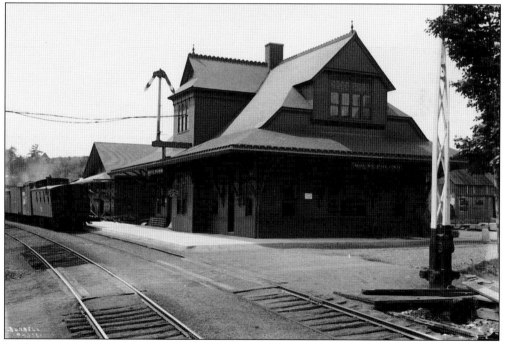

In this companion image from June 1906, a freight train is seen departing Mount Pocono. Unfortunately, this ornate wooden depot was demolished in 1937 to make room for a highway-widening project on nearby Pennsylvania Route 611. (Image C7, Watson Bunnell.)

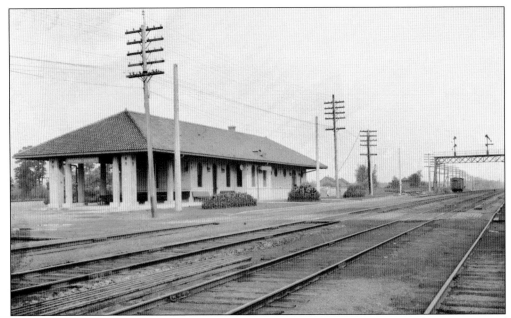

Located approximately three miles west of Mount Pocono, the Pocono Summit depot was one of the first Lackawanna Railroad stations to be constructed primarily of concrete. The station is seen in this west-facing view shortly after its 1911 completion. Beyond the station, tracks diverging to the left connected the Lackawanna with the Wilkes-Barre & Eastern Railroad, a subsidiary of the New York, Susquehanna & Western Railway. (Image B1159, Watson Bunnell.)

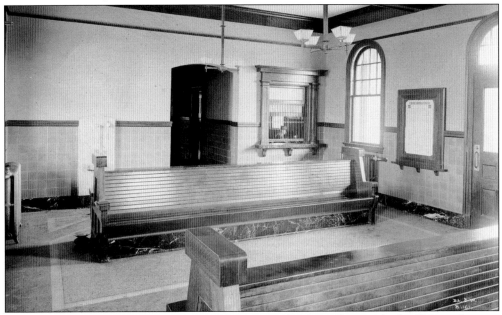

This c. 1911 image shows the quaint waiting room and ticket office inside the Pocono Summit station. Modern amenities include electric lights and steam radiators. The depot was spared demolition after the cessation of passenger service and, after years of dormancy, was renovated in 1987 as a destination for Steamtown passenger excursions. That service lasted only one year, and the station was boarded up once again. (Image B1161, Watson Bunnell.)

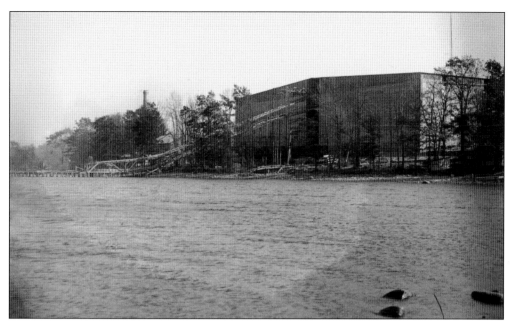

Prior to mechanical refrigeration, large blocks of ice were used to refrigerate railroad cars transporting perishable items. During the winter months, ice would be cut and harvested from frozen lakes in the Poconos and stored in icehouses, such as this unidentified facility. Short spurs were often constructed to reach these lakeside facilities, where refrigerated cars would have ice blocks several feet thick stacked inside. (Image C2351, Watson Bunnell.)

While destructive in and of itself, a fire at an unidentified icehouse has provided an otherwise impossible look at the contents of an icehouse around 1910. Blocks of ice were stacked on top of each other while in storage. In the foreground is a compressor engine, used to maintain refrigeration throughout the year. (Image C1144, Watson Bunnell.)

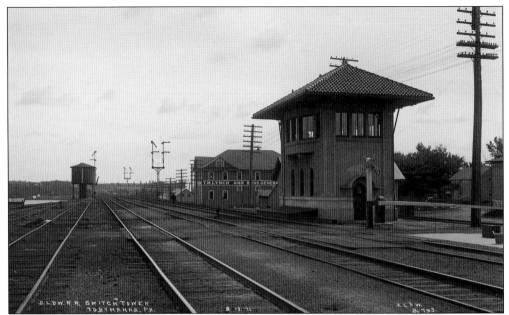

In the days before automation, switching a train from one track to another was accomplished by manually operating a series of pushrods from a nearby tower. This 1911 photograph shows a typical Lackawanna concrete tower in Tobyhanna. So-called interlocking towers such as this dotted the railroad and could be found wherever there was a series of switches together. (Image B793, Watson Bunnell.)

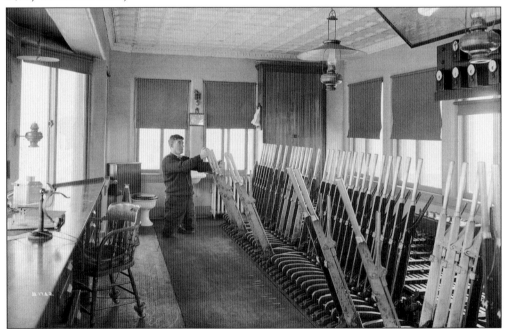

The interior works of the Tobyhanna interlocking tower are shown in this undated image. A tower operator would push the levers seen here to activate the switches below at trackside. Note the bell on the wall behind the operator, which would ring as a train was approaching the territory controlled by the tower. (Image B1742, Watson Bunnell.)

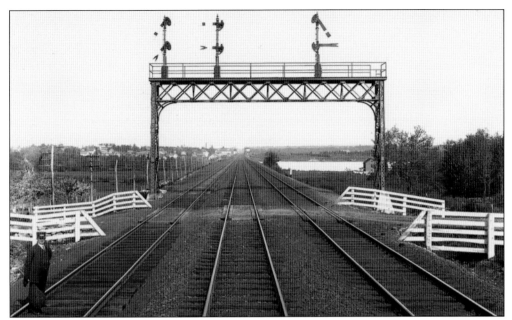

Looking west near Tobyhanna in May 1915, photographer Bunnell illustrates the signaling aspect of interlocking tower operation. The angled blades atop the poles were called semaphores and conveyed speed indications to engineers on moving trains. Both the tower and station at Tobyhanna remain standing, with the depot often being a destination for Steamtown excursion trains. (Image C2663, Watson Bunnell.)

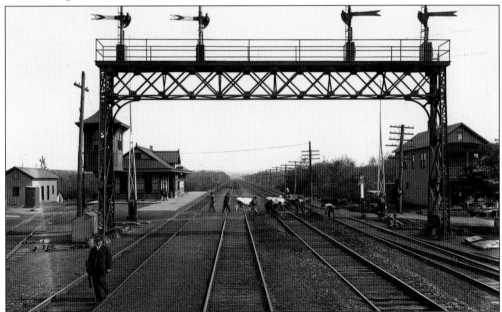

For the nearly 12 miles, beginning at Pocono Summit and stretching past Gouldsboro, the Lackawanna Railroad maintained a nearly straight and relatively level stretch of track that stood in stark contrast to the winding grades on either side of this mountaintop plateau. In this May 1915 image, the photographer is looking west toward Gouldsboro station, which has also been restored in recent years. (Image 2662, Watson Bunnell.)

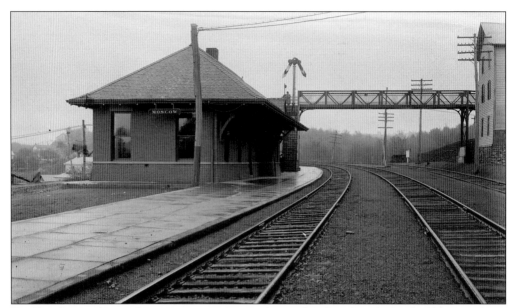

To allow for greater speeds, it was not uncommon for a railroad grade to be banked like a modern-day racetrack. Super elevation, as it was called, is evident in this June 1917 view at Moscow looking eastward. Just beyond the station is a pedestrian bridge constructed to allow passengers to safely cross over the high-speed curve and reach Moscow's downtown, located on the opposite side of the tracks. Today, the 1904 brick station is a frequent destination for Steamtown excursion trains. (Image C4085, Watson Bunnell.)

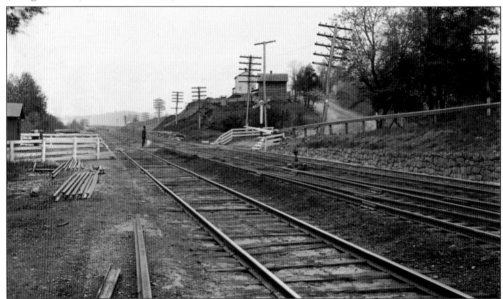

Approximately 10 miles east of Scranton is the town of Elmhurst. Several industries once occupied this area, including a tannery and furniture factory, supported by the surrounding timberlands. Once the natural resources were depleted, the town transitioned into a residential community whose most notable landmark was the Elmhurst Reservoir. A substantial dam and spillway were constructed in 1889 and are partially visible in the background of this 1909 photograph. (Image C425, Watson Bunnell.)

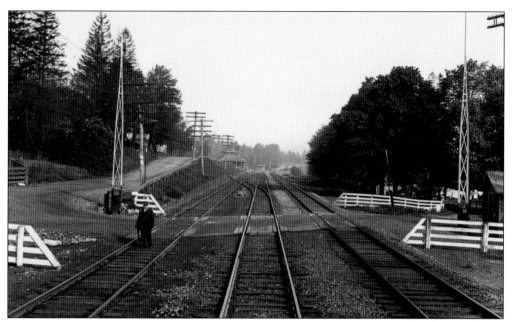

In this view looking west toward Elmhurst in May 1915, a rural grade crossing has captured the photographer's attention. During the Lackawanna Railroad's heyday, the company sought to eliminate as many of these crossings as possible. Subsequent years would see the construction of a steel bridge over the railroad at this location, which is still used today by traffic on Pennsylvania Route 435. (Image C2661, Watson Bunnell.)

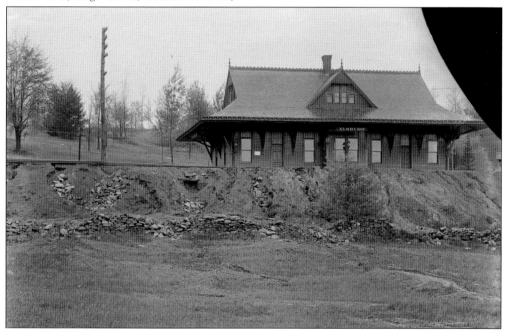

Although damaged, this May 1909 image provides an excellent view of the seldom-photographed passenger station at Elmhurst. Although not much has been recorded about this charming little depot, a construction date of 1894 is often quoted. Unfortunately, the station was demolished sometime after World War II. (Image C430, Watson Bunnell.)

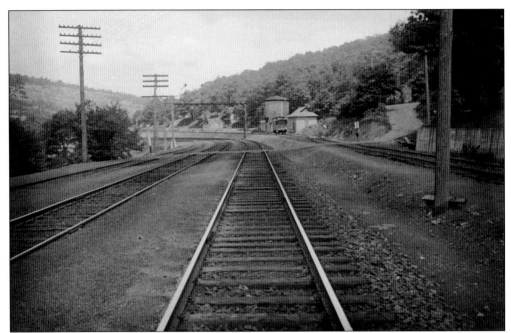

Just a few miles from Scranton, the village of Nay Aug was the last station west of the city. Nay Aug was home to a small yard, the start of the Lackawanna's Winton branch, as well as a sizable brickworks. In this westward view from June 1916, a lone caboose is positioned next to the water tower on the Winton branch. (Image C2315, Watson Bunnell.)

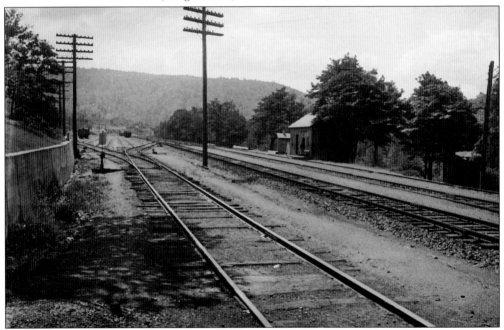

Taken on the same date and from the same position as the preceding image, the photographer has turned his camera to face east, capturing the yard at Nay Aug. The yard was primarily used to sort cars moving to and from the Winton branch. To the right-hand side of the image is the unassuming Nay Aug passenger station. (Image C2312, Watson Bunnell.)

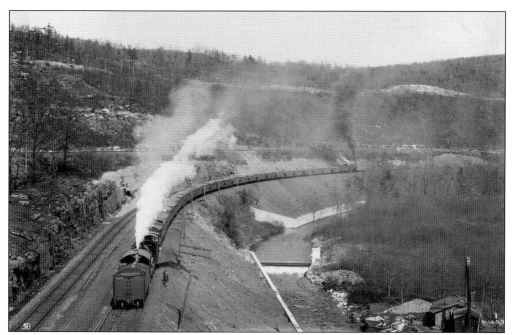

During the Lackawanna Railroad's modernization program, the physical roadbed was widened to allow for less restrictive curvature and additional tracks. About one mile west of the yard at Nay Aug, a heavy coal train heads east with three helper engines at the rear. The amount of landfill required to accommodate the right-of-way is evident on the right as it slopes toward Roaring Brook below. The Erie Railroad's Jessup branch crosses the Lackawanna at this location, on a trestle that provided the vantage point for this c. 1912 image. (Image B1403, Watson Bunnell.)

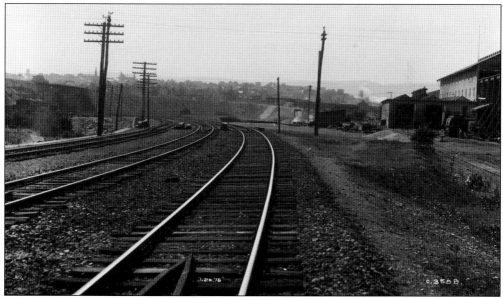

Although it maintained no station here, the Lackawanna Railroad did bisect a small part of Dunmore, just outside the city of Scranton. Visible to the right of this January 1916 image is a portion of the Erie Railroad's massive Dunmore Shops. The bridge in the distance connected the facility with the Erie's Wyoming Division main line. (Image C3598, John Anneman.)

43

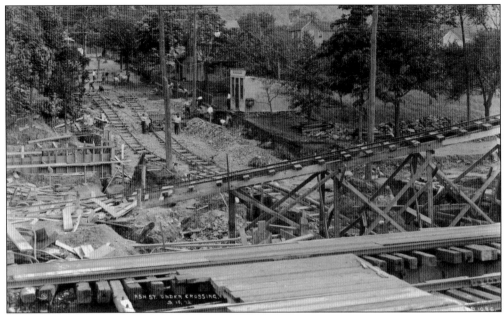

What looks like a primitive amusement park ride is actually a complex construction project at Ash Street in Scranton. As with many locations, the Lackawanna Railroad decided to eliminate the at-grade crossing with an underpass at this site. The roller coaster–like tracks are temporarily in place to move materials around the worksite, which was photographed on July 16, 1912. (Image B1086, Watson Bunnell.)

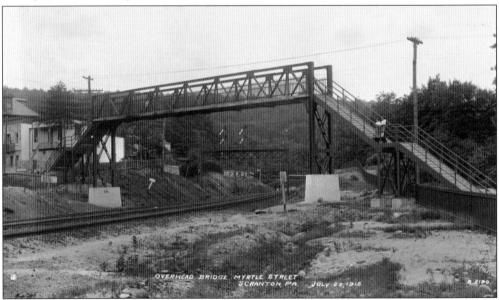

At Myrtle Street, just few hundred yards west of Ash Street, the Lackawanna saw fit to eliminate another at-grade crossing. At this location, a pedestrian bridge has been erected to allow safe passage across the main line. This location likely saw quite a bit of foot traffic as a large silk mill occupied land just out of view across the tracks. The bridge remained in service for several decades after this July 1915 image was taken, but it was removed in the 1970s. In 1988, the Myrtle Street grade road crossing was reinstalled at this spot. (Image B2190, John Anneman.)

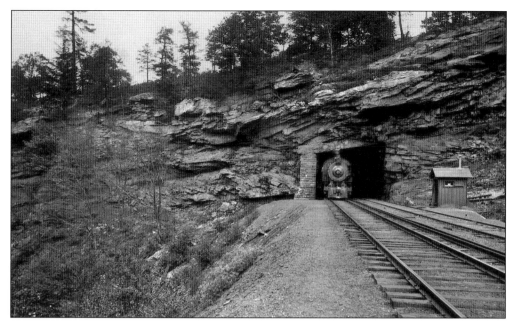

Despite its name, the Nay Aug Tunnel was located entirely within the Scranton city limits. Completed in 1856, the bore was one of the earliest railway tunnels in the nation. In this c. 1900 image, a Lackawanna freight train is moving west toward Scranton and has just exited the tunnel near a watchman's shanty. By this time, it was apparent that the two-track main line east of Scranton had become inadequate for the high volume of coal traffic leaving the city. (Author's collection.)

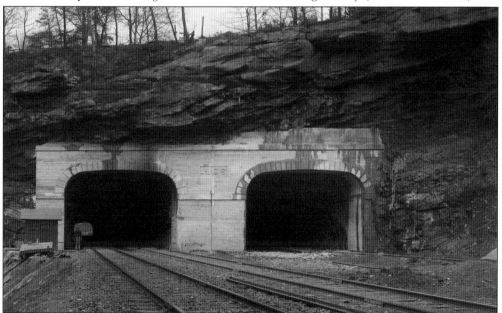

In this December 1906 image, the Lackawanna Railroad has just completed a companion tunnel to the right of the 1856 original. Interestingly enough, the decorative concrete facade was only added to the west end of the tunnel. In 1955, floodwaters caused by Hurricane Diane would destroy the grade leading to this location. During reconstruction efforts, the second tunnel was no longer needed, and the grade was rebuilt only to the original bore. (Image B40, Watson Bunnell.)

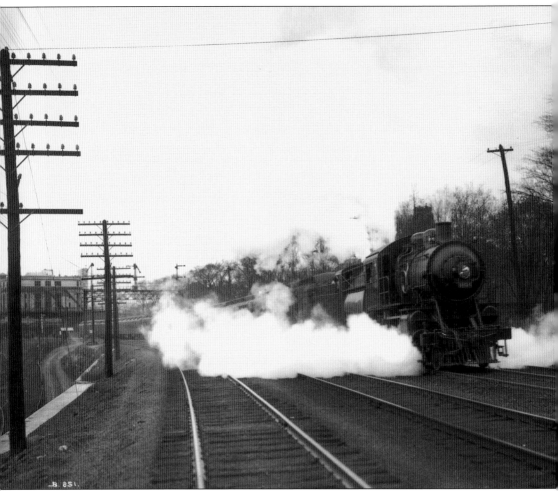

In this c. 1912 image, an express passenger train, quite possibly the Lackawanna Railroad's flagship Lackawanna Limited, is departing Scranton for points east. To the rear of the train is the company's passenger station and Scranton Division headquarters, completed in 1908. The immaculate train and surrounding property are indicative of the prosperity enjoyed by the Lackawanna at this time. The lack of black smoke was common to the railroad's anthracite-burning locomotives and became a hallmark of the company's passenger service. (Image B851, Watson Bunnell.)

Five

SCRANTON

Scranton can truly be considered the heart and soul of the Delaware, Lackawanna & Western Railroad. Thes city was the birthplace of the Lackawanna Railroad, and the source of its most lucrative commodity, anthracite coal. Roughly 85 percent of the nation's total hard coal supply was mined from northeastern Pennsylvania. The company's moniker, "the Road of Anthracite," adorned buildings and railroad cars, while Phoebe Snow—a character born of the railroad's advertising department—extolled the cleanliness of hard coal while dressed in a formal white gown.

To sort, process, and deliver the so-called black diamonds, the Lackawanna developed an extensive infrastructure in the city. City Yard, the site of the railroad's locomotive repair shops, received most of the city's carload freight, which included perishable commodities, such as milk, fruits, and vegetables and meat products. Keyser Valley Yard was the location of a large railcar maintenance and construction shop. Hampton and Taylor Yards were dedicated largely to the anthracite coal trade.

Upon the decline of anthracite traffic after World War II, most of the yards were repurposed or eliminated outright. Hampton Yard was abandoned altogether, while Taylor Yard is now operated as an intermodal freight facility. Many of the buildings that comprised the Keyser Valley shops are now used for other manufacturing purposes but are served by rail. The shops at City Yard were downsized and converted to diesel maintenance. Closed by 1980, City Yard is now the home of Steamtown National Historic Site.

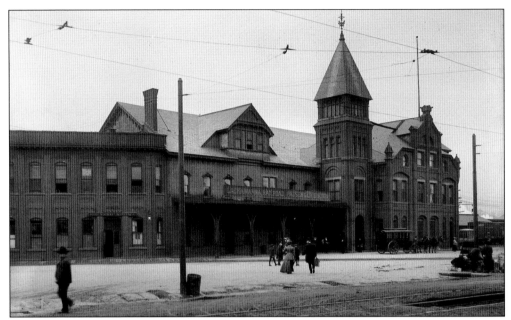

This c. 1906 photograph depicts the 1864 passenger station constructed by the Lackawanna Railroad on the 100 block of Lackawanna Avenue in downtown Scranton. In 1909, this building would be demolished, supplanted by a newer facility some five blocks to the east. Shortly thereafter, a freight-only station would be constructed at this location. That building, in turn, would be demolished during the 1960s and replaced by a state-owned office building. (Image B316, Watson Bunnell.)

The Lackawanna Railroad's company store was located at the confluence of Lackawanna Avenue, Ridge Row, and Jefferson Avenue on a portion of the land that would be become the site of the railroad's new passenger station. The view in this c. 1906 photograph looks west toward Lackawanna Avenue. (Image B20, Watson Bunnell.)

Construction has already begun at the site of the Lackawanna Railroad's new passenger station in this wintry image from late 1906 or early 1907. The photographer has taken to the Spruce Street Bridge to capture this scene, which includes the Lackawanna County Courthouse, with its tall spire, to the right. On the far left of the image is a home that would later see use as a Lackawanna Railroad–sponsored YMCA. (Image B47, Watson Bunnell.)

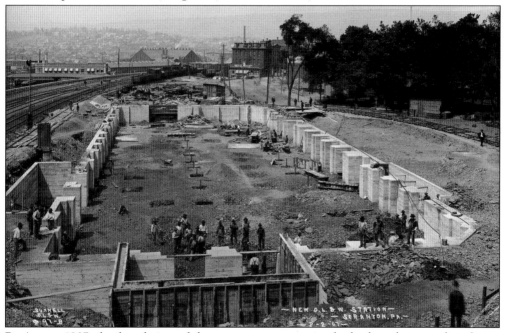

By August 1907, the foundation of the new passenger station had taken shape, and workmen are excavating holes where structural beams will later be set. The Lackawanna Railroad's repair shops at City Yard can be seen in the background behind the construction site. Also visible in the background to the left is the passenger station of the Lackawanna & Wyoming Valley Railroad, an electric line that ran south from Scranton to Wilkes-Barre, Pennsylvania. (Image B97, Watson Bunnell.)

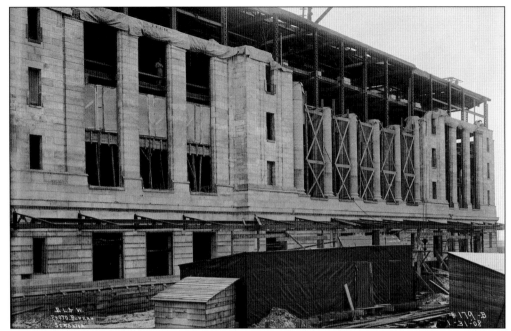

The Scranton station's steel superstructure is largely complete, and application of the building's brick exterior and limestone facade is well underway in this image from January 1908. This is the north side of the building, which will face a reconstructed intersection of Lackawanna and Jefferson Avenues. (Image B179, Watson Bunnell.)

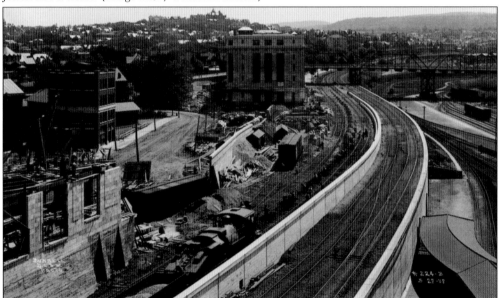

This eastward view from May 1908 provides a detailed look at how the Lackawanna's main line was routed around the new passenger station. The uppermost elevated tracks on the left would be used by passenger trains stopping at the station from both the east and west. In the center of the image are the tracks that carried freight trains around the station and into City Yard. On ground level are tracks belonging to the Lackawanna & Wyoming Valley Railroad. (Image B224, Watson Bunnell.)

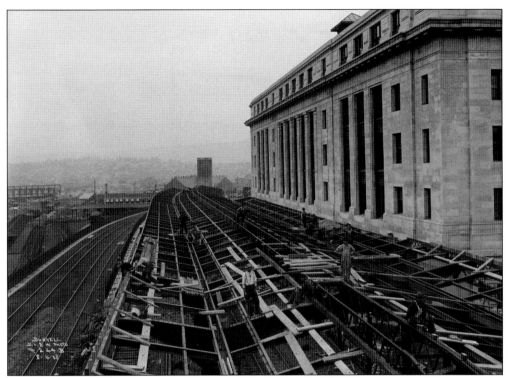

The race is on to finish work on the grand depot prior to its December 1908 opening. In this August 1908 image, workers construct covered platforms known as a Bush train shed. Named for their designer, Abraham Lincoln Bush, these types of platforms allowed passengers to remain covered from the elements while a channel permitted smoke from locomotives to escape into the atmosphere. (Image B244, Watson Bunnell.)

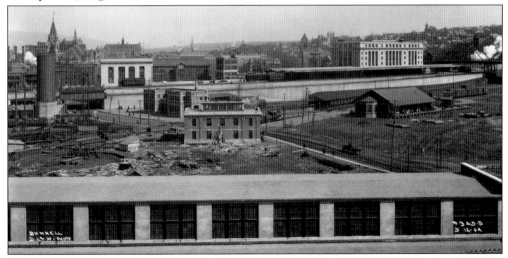

The new station and headquarters are in full operation in this March 1909 view. The completed station is clearly visible on the right. The smaller light-colored structure on the left is the Railway Express Agency building. Below that is the passenger station belonging to the Lackawanna & Wyoming Valley Railroad. In the immediate foreground, construction of the Lackawanna Railroad's new shop complex is underway. (Image B345, Watson Bunnell.)

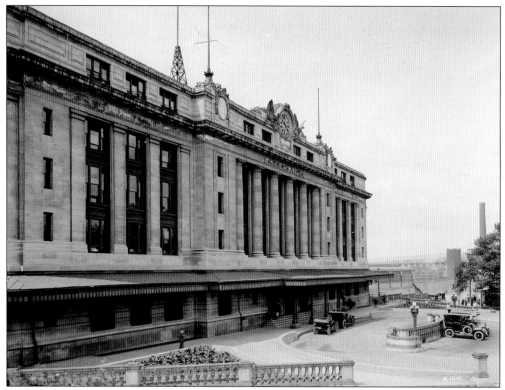

The street-facing side of the new passenger station presents an image of grandeur in this c. 1913 image. Note the tower atop the building, erected by the Marconi Radio Company in 1913 to explore the possibilities of communicating with moving trains by radio. The tower was removed sometime before 1923, when a sixth floor was added. (Image B1527, Watson Bunnell.)

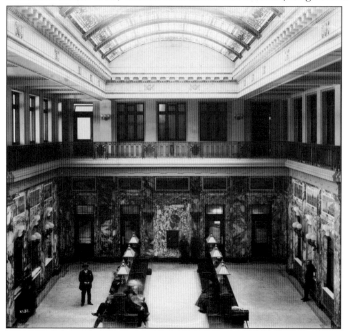

The interior of the Lackawanna Railroad's new architectural masterpiece was no less impressive than its exterior. Several varieties of Italian marble lined the walls surrounding a mosaic tile floor in the main waiting room. Overhead, a vaulted stained-glass ceiling allowed rays of sunlight to cascade over 36 Grueby Faience murals that depicted scenes along the railroad. (Image X131, photographer unknown.)

A passenger train is ready to depart from the west end of the Scranton station platform in this image from late 1908 or early 1909. The open ventilation design of the Bush train shed is evidenced here by the notches in the platform roof that allowed the locomotive exhaust to escape while still keeping waiting passengers out of the elements. (Image C371, Watson Bunnell.)

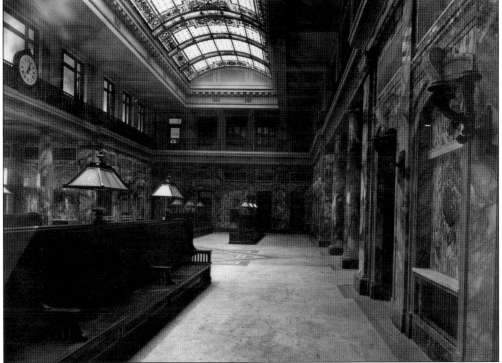

The Scranton waiting room appears dingy and ill maintained in this undated image. The station saw its final passenger train depart in 1970, after which point the building was used for offices and storage before being shuttered altogether. Conversion of the former station into a Hilton began in 1982, with the facility opening its doors on New Year's Eve 1983. Today, the hotel is operated as part of the Radisson chain and is a major tourist draw. (Pennsylvania Historical and Museum Commission photograph.)

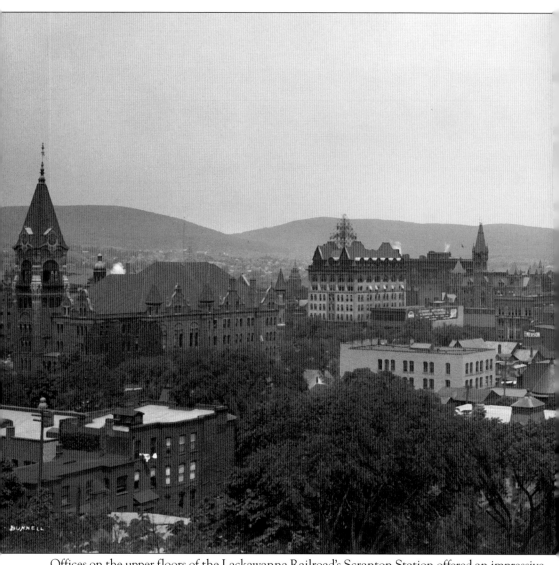

Offices on the upper floors of the Lackawanna Railroad's Scranton Station offered an impressive view of a modern city, as seen in this c. 1910 image. The dominant building on the left side of the image is the Lackawanna County Courthouse, constructed in 1884. To the right of the courthouse

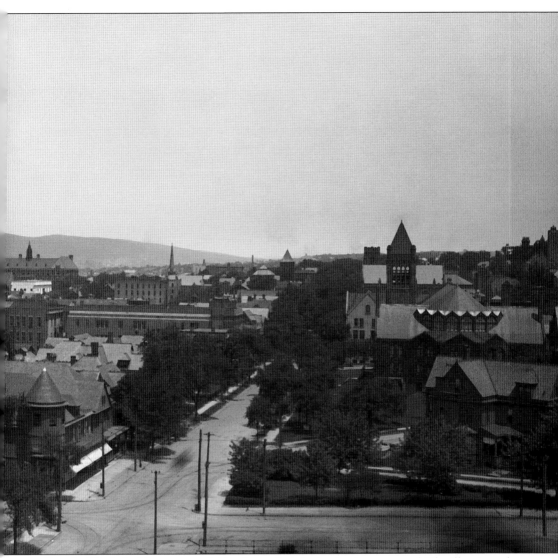
is the Board of Trade building, upon which a large electric sign has been erected. The illuminated sign would display various slogans over the years, such as, "Watch Scranton Grow," or "Scranton the Electric City," a nod to the city's early use of electricity. (Image L1, Watson Bunnell.)

In 1909, after the completion of its new passenger station, the Lackawanna would raze the outdated 1864 depot, located six blocks to the west. In its place, the railroad built a freight house and yard used primarily for delivering perishable goods to the surrounding wholesale district. In this c. 1909 image, two dairy wagons and a multitude of refrigerated railroad cars are positioned on the team tracks behind the depot. (Image B663, Watson Bunnell.)

The west end of Scranton's wholesale district is seen here on May 11, 1908. On the opposite side of the railroad tracks are buildings belonging to the Dickson Manufacturing Company, an early locomotive builder that became part of the American Locomotive Company in 1901. In 1909, locomotive construction ceased in Scranton, and the buildings became a silk mill. This location is near the present-day entrance to Steamtown National Historic Site. (Image B218, Watson Bunnell.)

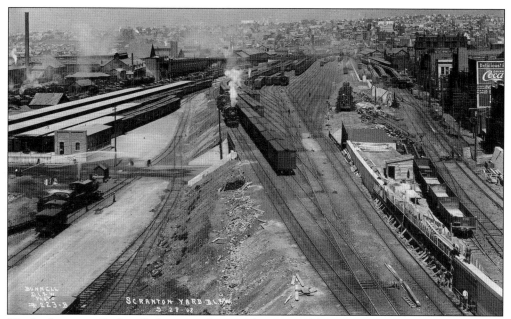

The Lackawanna Railroad's Scranton City Yard is pictured here on May 28, 1908. On the right-hand side of the image, work is progressing on the main line tracks that would bypass the yard. On the left side of the image is the less-than-carload freight transfer facility. The company's engine servicing facilities and locomotive coaling trestle are immediately behind the freight platforms. (Image B223, Watson Bunnell.)

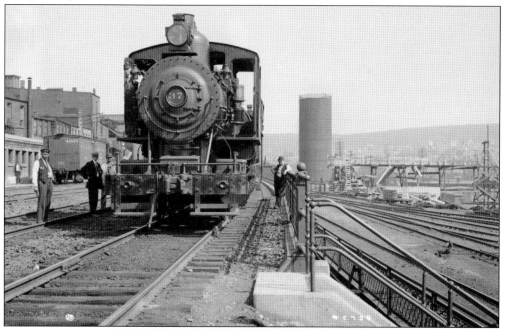

Railroad officials pose with a switcher crew along the now complete elevated main line through Scranton on August 11, 1910. Locally known as the "China Wall," the new right-of-way bypassed several road crossings and allowed passenger trains to circumvent the freight yard. Construction of the new erecting shops is visible to the right. (Image C738, Watson Bunnell.)

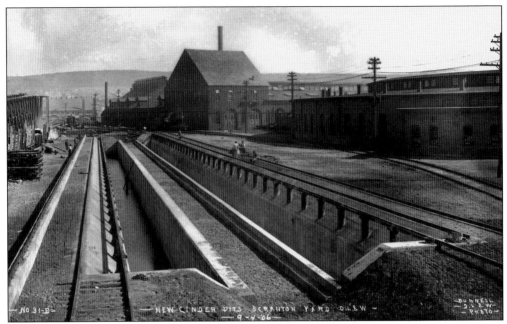

In September 1906, construction was nearly complete on a new set of cinder pits adjacent to the downtown Scranton shop complex. Waste cinders and ash from the coal-fired locomotives were used for a number of purposes including landfill and cinder block manufacturing. At this location, locomotives would pull over the pits and dump their ash and cinders, which were extinguished by pools of water below. A clamshell crane would travel along the two outermost rails, collecting the material for reuse. (Image B31, Watson Bunnell.)

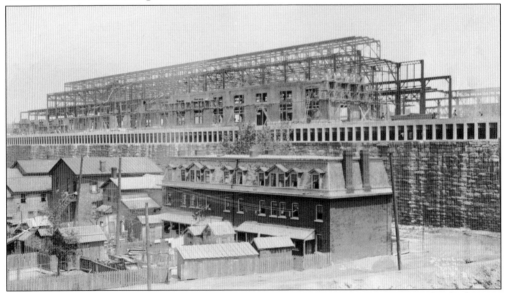

By 1900, Scranton's Civil War–era repair shops were rendered inadequate by both the size and quantity of locomotives being operated by the Lackawanna. In 1908, the railroad began construction on a much larger repair and maintenance facility on land previously occupied by Lackawanna Iron & Steel. In May of that year, the steel skeleton of the new pattern shop towers over the neighborhood below. (Image B219, Watson Bunnell.)

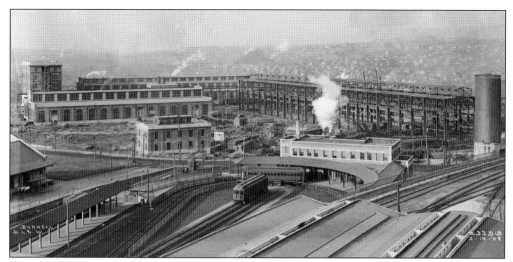

Construction on the main erecting shop building is well underway in this February 1909 image taken from the roof of the nearby passenger station. The large steel frame will become the erecting shop, while the perpendicular foundry and pattern shop buildings are nearing completion. The separate two-story building is the company's new laboratory. In the center of the image is the circular station of the Lackawanna & Wyoming Valley Railroad. (Image B335, Watson Bunnell.)

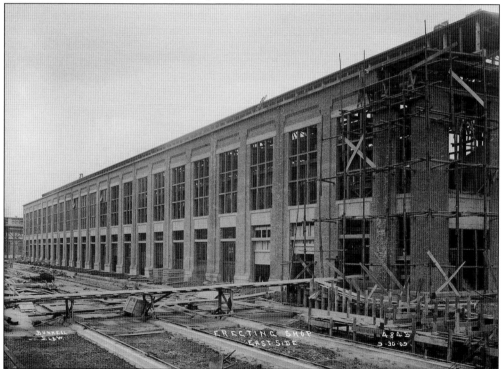

The brick facade of the erecting shop building is nearly complete in this September 1908 view. In the foreground are rails of the yet-to-be-installed transfer table. The transfer table was essentially a railroad bridge on wheels that could move horizontally to permit access to the building's 22 individual bays. A man in dark clothing on the scaffolding to the right illustrates the sheer enormity of this structure. (Image B484, Watson Bunnell.)

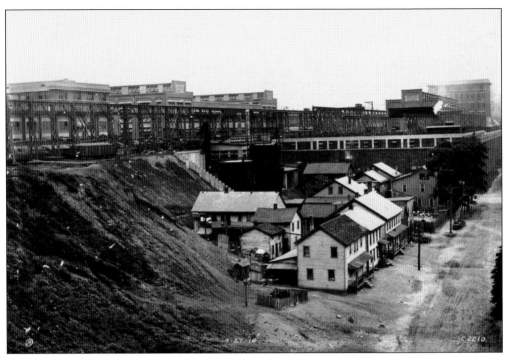

Building the new locomotive shop in Scranton required a large, flat tract of land adjacent to the railroad. Since such parcels of land did not exist in Scranton, the Lackawanna Railroad was forced to build an artificial plateau upon which to build the complex. That effort is illustrated in this July 1914 image of the facility's south side. (Image C2210, John Anneman.)

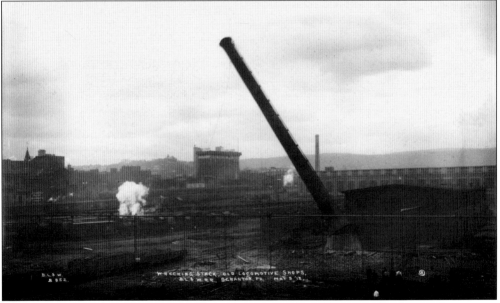

Once the new shops were online, many of the older buildings became redundant and were torn down or converted for other uses. On May 9, 1912, one of the final acts of demolition was the toppling of an old smokestack. Photographer Bunnell caught the process as it was happening, as evidenced by the blur created by the falling stack. (Image B852, Watson Bunnell.)

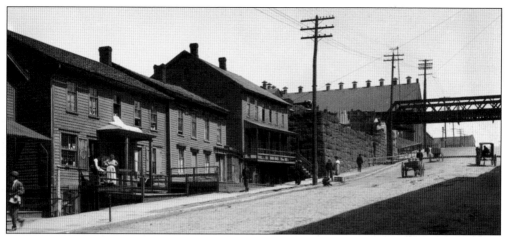

Shop construction is beginning to encroach upon a neighborhood along South Washington Avenue in this May 1908 photograph. Beyond the wood-frame buildings is the cut-stone retaining wall that will enable the Lackawanna to level a sizeable parcel of land for its expansion. The wooden trestle connects the original 1865 shop complex on the left with the under-construction facility to the right. Upon completion of the new shop buildings, the wooden bridge would be replaced with a steel span that accommodated several tracks side by side. (Image C235, Watson Bunnell.)

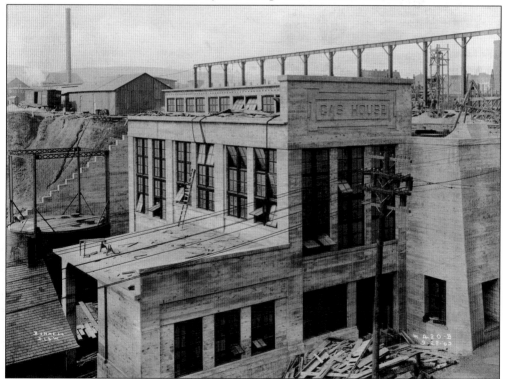

In just over a year, the Lackawanna Railroad's Gas House has replaced the buildings in the previous photograph. The Gas House generated water gas by spraying water vapor over burning coal. The resulting mixture was then used as fuel throughout the new shop complex. The concrete building exists today and currently houses the heating and refrigerating systems for Steamtown National Historic Site. (Image B480, Watson Bunnell.)

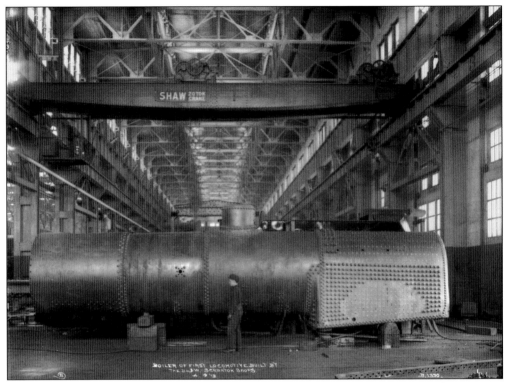

One of benefits of the new shop complex was the ability to construct entirely new locomotives on-site. The boiler for the first of these projects is pictured in the erecting shop on April 19, 1913, and bears the caption, "Boiler of the first locomotive built by the DL&W Scranton Shops." (Image B1390, Watson Bunnell.)

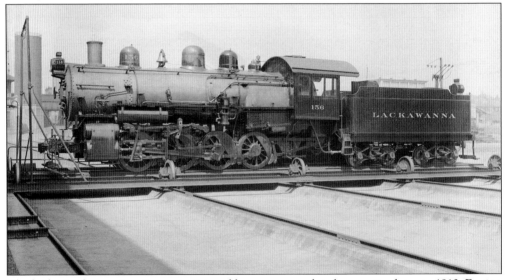

The boiler in the previous image is pictured here as a complete locomotive later in 1913. Engine 156 was known as a switcher, the type of locomotive intended to sort railroad cars within a yard and not travel long distances. The locomotive is seen on the transfer table located on the east side of the erecting shop. (B1442, Watson Bunnell.)

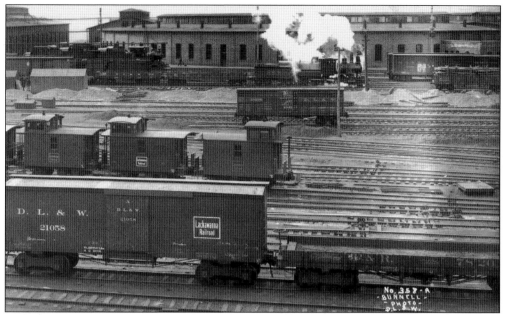

A locomotive passes behind City Yard's 1902-constructed roundhouse. The 1902 roundhouse replaced a smaller version at this location that was built in 1865. The 1865 roundhouse itself had been erected after its 1855-era predecessor was deemed inadequate. This photograph, though undated, was likely taken in 1905, as a new coaling trestle would be constructed a year later near the center of the area pictured, thereby obscuring this view. (Image A358, Watson Bunnell.)

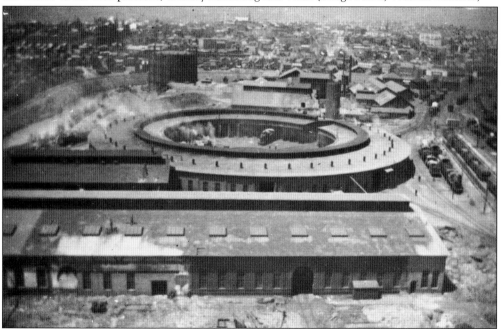

After the 1910 completion of the new erecting shop complex, some of the original 1865-era buildings were demolished. The section adjacent to the 1902 roundhouse, however, was reconfigured for smaller repair jobs and machine work. Construction and demolition debris in front of the building date this photograph to about 1912. (Pennsylvania Historical and Museum Commission photograph.)

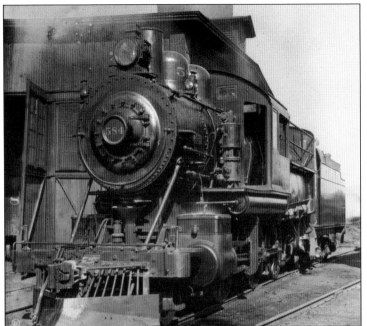

Unlike an erecting shop, a roundhouse could only perform repairs that did not require the use of an overhead crane. The building was much better suited to its intended purpose: storing locomotives for short periods of time while they underwent routine maintenance or awaited their next call to service. In this c. 1912 image, engine 584 pauses near the current location of the Steamtown National Historic Site Visitor Center. (Image C1062, Watson Bunnell.)

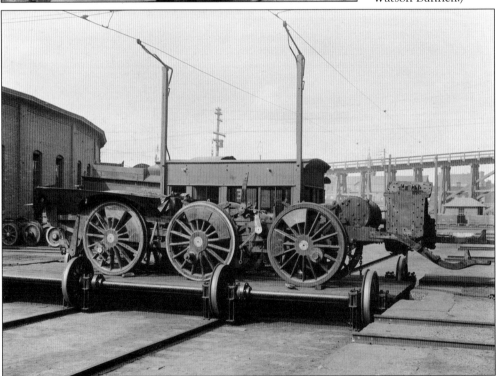

A small transfer table was located between the 1902 roundhouse and the original 1865-era shops. This allowed workers to move locomotives around the shop without having to disrupt operations in the adjacent rail yard. The exact date of the table's removal is unknown but either the c. 1910 refit of the older shop buildings or a 1917 roundhouse enlargement likely ended its use. (Image B119, Watson Bunnell.)

Upon the 1910 completion of the new shop complex, that facility was connected to other buildings in the yard via an underground railway. Used to move supplies and equipment, the railroad was powered by electric locomotives, as seen here in December 1910. (B717, Watson Bunnell.)

In addition to its primary use for locomotive servicing and repair, City Yard was also home to equipment used to repair and maintain the Lackawanna's rail lines in the Scranton area. Known as maintenance of way, the equipment included the crane seen here. Locomotives behind the crane are staged near the location of the original 1855 Scranton roundhouse, which has long since been demolished and replaced with a 90-foot turntable. (Image B1746, Watson Bunnell.)

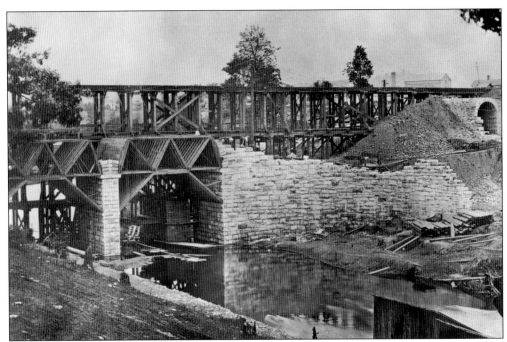

Several obstacles precluded any westward expansion of the Lackawanna Railroad's City Yard. Just beyond the artificial plateau upon which the yard was constructed lie tracks belonging to the Delaware & Hudson Railroad, bordered closely by the Lackawanna River. For its main line to cross the river, the Lackawanna first constructed a wooden trestle in the 1850s. That trestle was soon replaced by a stone arch bridge, as seen in this late-19th-century north-facing view. (Author's collection.)

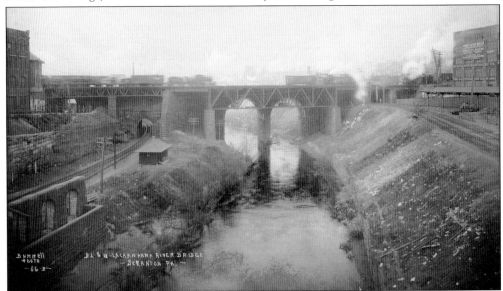

As more tracks were needed, the Lackawanna added additional steel spans next to the stone arch bridge. This c. 1905 south-facing view illustrates the topography at the west end of City Yard. In the center of the image is the Lackawanna River. On the left side of the river is the Delaware & Hudson main line, which passed under the bridge via a narrow tunnel. The Central Railroad of New Jersey's Scranton terminal is on the opposite bank. (Image B66, Watson Bunnell.)

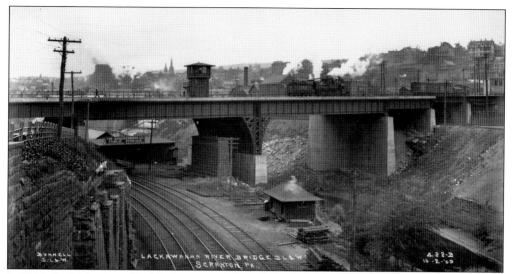

In 1908, the Lackawanna Railroad constructed a wide steel-and-concrete bridge over the Lackawanna River and the railroads that followed its banks. This October 1909 photograph depicts the new span, now commonly called "Bridge 60" due to its designation as the 60th bridge in the railroad's Scranton Division. The photographer is positioned above the Delaware & Hudson line, which has expanded to include three tracks upon the removal of the tunnel shown in the previous image. (Image B488, Watson Bunnell.)

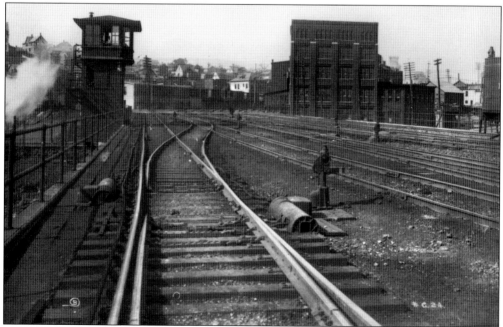

The network of switches atop the new Lackawanna River Bridge was controlled by an interlocking tower attached to the south side of the span. One of the modern conveniences that came with the new bridge was the system of air-powered switches. No longer did the tower operator need to muscle levers into place while arranging train movements. This c. 1910 view looks west across the bridge. Tracks diverging to the right included the main line to New York, while those curving to the left allowed access to Taylor Yard and the Bloomsburg branch. (Image G24, Watson Bunnell.)

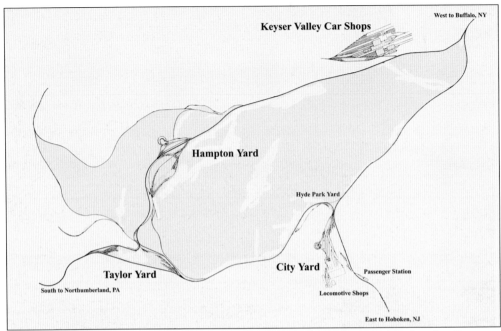

This map shows the major branches and yards operated by the Lackawanna Railroad in Scranton by 1910. The shop complex at City Yard handled mostly locomotive maintenance and merchandise freight. In turn, the Keyser Valley Car Shops handled railroad car repair and construction. Hampton Yard processed both general freight and outbound loaded coal, while Taylor Yard handled empty cars destined for the mines. (Author's collection.)

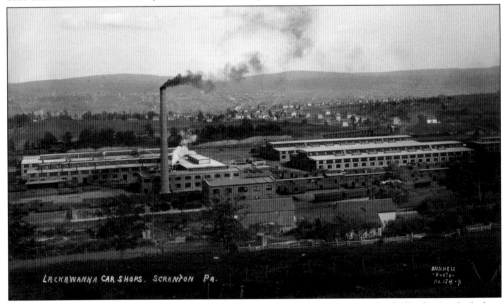

The Keyser Valley Car Shops are pictured around 1905 from a nearby hillside. Included in the complex are a foundry, blacksmith shop, lumberyard, carpentry shop, and paint shop. The complex opened in the 1880s and would continue in use until approximately 1960. One of the most notable products of Keyser Valley was a series of cabooses built in the 1950s atop tender frames from retired steam locomotives. (Image A184, Watson Bunnell.)

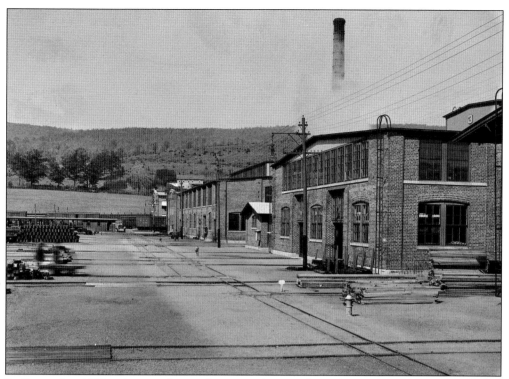

In September 1908, a lone worker pushes a supply cart along a narrow gauge tramway within the Keyser Valley Car Shops, causing the blur to the left in the image. Also of note are the fire hydrants dotting the area. Connected to the city's water system, these hydrants would hopefully enable workers to extinguish a fire in short order, lest it be allowed to spread to the vast stockpiles of wood nearby. (ImageB245, Watson Bunnell.)

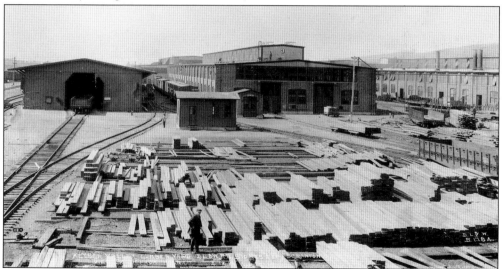

The lumberyard is full of activity in this image from April 1913. Stacks of lumber, most likely yellow pine, are staged for quick access. The year 1914 is still very much the era of wooden freight car construction, despite new all-steel cars being introduced at the time. (Image B1784, Watson Bunnell.)

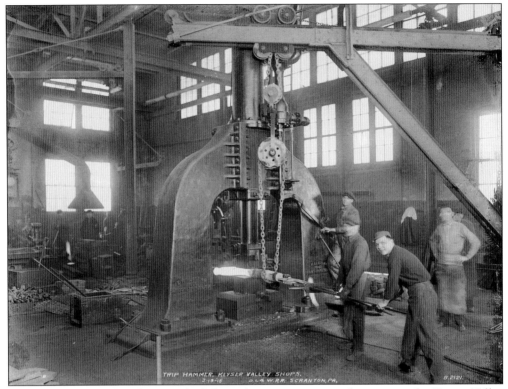

Employees handle white-hot metal while working a massive trip hammer in the Keyser Valley blacksmith shop. The massive hammer was raised by hydraulic pressure and then released, allowing gravity to provide the striking blow. The machine was likely new when this photograph was taken on March 19, 1915. (Image B2121, Watson Bunnell.)

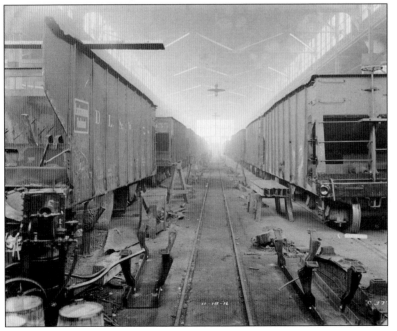

The Keyser Valley Car Shops appear quite busy in this image taken on November 18, 1916. Undergoing repair are a number of hopper cars used by the Lackawanna Railroad to move coal to market. (Image C3775, John Anneman.)

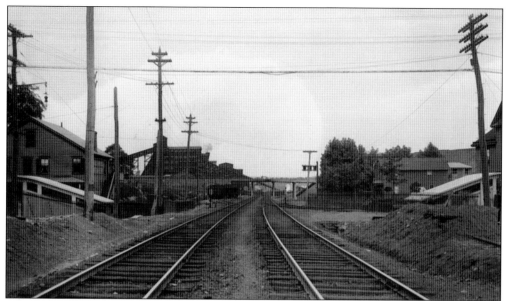

In addition to linking the car shops connected with the rest of the Lackawanna Railroad, the Keyser Valley branch was also a vital link in the company's Scranton rail network. The branch allowed westbound coal trains leaving the nearby Hampton Yard to bypass a circuitous route through Taylor and access the main line near Clarks Summit. The Keyser Valley also served several coal breakers, such as the one seen towering over Jackson Street in July 1914. (Image C2214, John Anneman.)

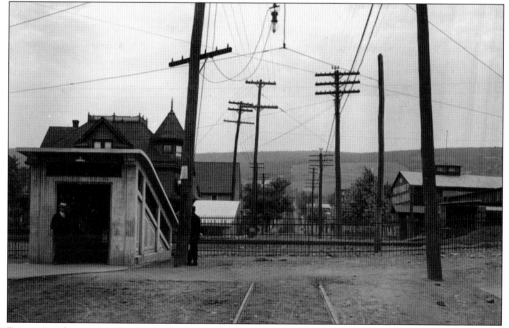

Due to its heavy traffic load, the Lackawanna Railroad worked to eliminate several crossings on the Keyser Valley branch. At Jackson Street, a crossing has been removed, with the railroad constructing an underground passageway to allow residents to safely cross under the tracks, while streetcar tracks dead-end in the foreground. (Image C2214, John Anneman.)

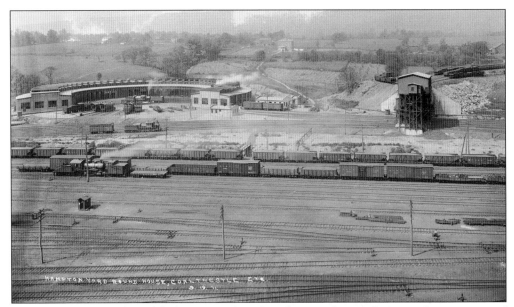

While somewhat deteriorated, this September 1911 photograph provides a priceless overview of the engine-servicing area at Hampton Yard. To the left is the half-circle roundhouse, while the coal tipple is to the right. In the background above the roundhouse is the Lackawanna Railroad's Hampton branch YMCA. Due to the surrounding topography, much of Hampton Yard was inaccessible by any other means than rail, so very few images of this facility were taken aside from those by the company. (Image B800, Watson Bunnell.)

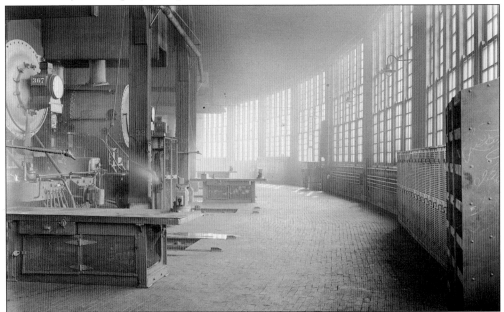

On March 13, 1914, several locomotives await their next call to service inside the Hampton roundhouse. Located over each locomotive are vents called smoke jacks, which allowed locomotives to remain under steam with lit coal fires inside the building, a practice brought about by the several hours required to bring an otherwise cold locomotive up to working steam pressure. (Image B1763, John Anneman.)

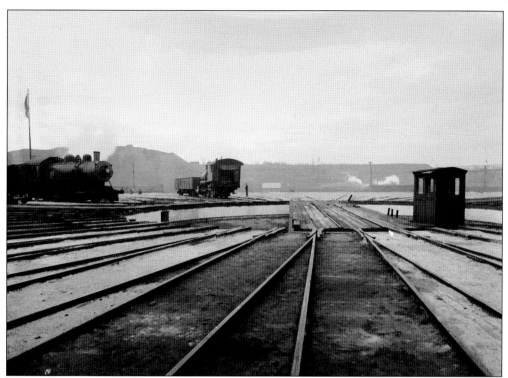

The Hampton Yard turntable area is surprisingly quiet in this May 2, 1917, image. The roundhouse itself is located behind the photographer, who pointed his camera eastward for this photograph. In the distance is a mountain of mine waste that provided a panoramic view of the yard as depicted on the preceding page. (Image C4048, John Anneman.)

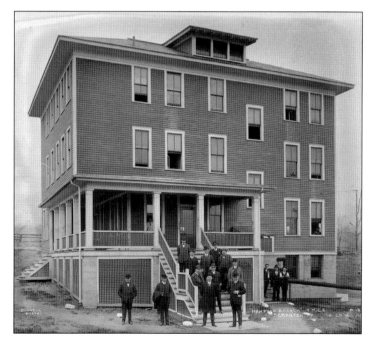

The Lackawanna Railroad's Hampton branch YMCA is pictured on April 29, 1914. Railroad-affiliated YMCAs were common during this period and were established to provide wholesome meals and overnight lodging for railroad employees in a moral environment. The YMCA building is the only structure associated with Hampton Yard that remains standing. (Image 1162, Watson Bunnell.)

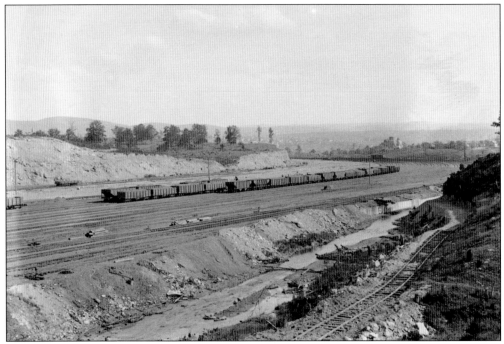

This c. 1908 image illustrates the sweeping curve that comprised much of Hampton Yard. On the far left, construction is underway for the new hump yard, which used gravity to propel railroad cars onto predetermined tracks by means of its sloped construction. (Image B593, Watson Bunnell.)

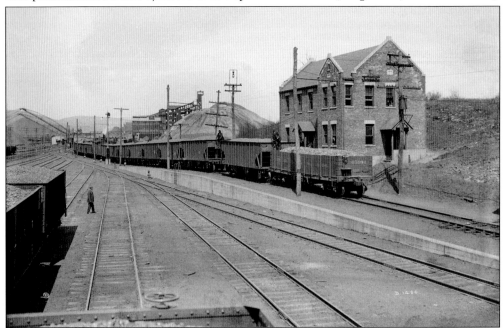

Photographer Bunnell climbed atop a loaded hopper car to capture this c. 1910 view of Hampton's hump yard as loaded coal cars are being pushed up the incline by a locomotive on the opposite end. Once at the top of the hump, cars will be cut off in different groups and carried by gravity toward various predetermined tracks. (Image B1400, Watson Bunnell.)

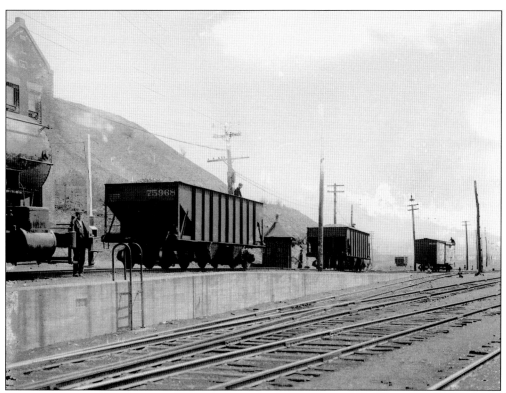

In this view, rolling cars have been separated and are heading downhill to various yard tracks. On each car is a railroad employee who will control the car's movement with a hand-operated brake. Many hump yards would later be equipped with mechanical retarders, which would grip the wheels of each passing car to slow them down, thereby eliminating the need for a rider on each car. (Image B1401, Watson Bunnell.)

This view, looking downhill toward the classification yard in September 1910, reveals the myriad of hand-operated switches used to sort moving railcars. This synchronized method of sorting cars required both a focused mind and brute strength. Communication between riders and switch operators was essential, as any cars sent down incorrect tracks would have to be retrieved by a locomotive. (Image B671, Watson Bunnell.)

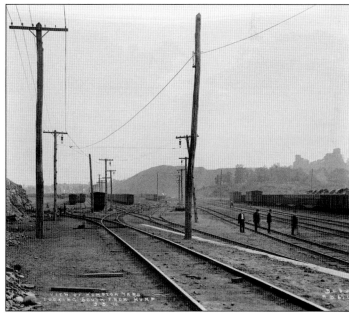

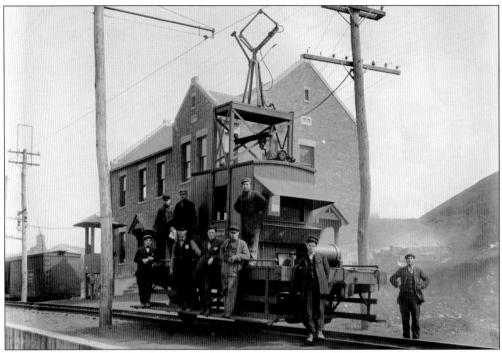

Due to the sizeable length of Hampton Yard, employees who had ridden cars to their destination tracks in the hump yard would often find themselves more than a mile from where they started. To eliminate the need for a laborious and time-consuming walk, the Lackawanna constructed an electric taxi of sorts that would ferry men back to the top of the hump yard, as pictured here around 1910. (Image B739, Watson Bunnell.)

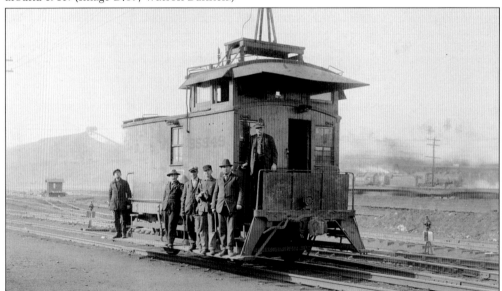

Never one to squander antiquated equipment unnecessarily, the Lackawanna Railroad built one of its Hampton Yard trolleys from an old four-wheeled caboose. With both labor and management posing for the photographer, this contraption was likely brand-new when this image was taken on October 21, 1918. (Image B2137, Watson Bunnell.)

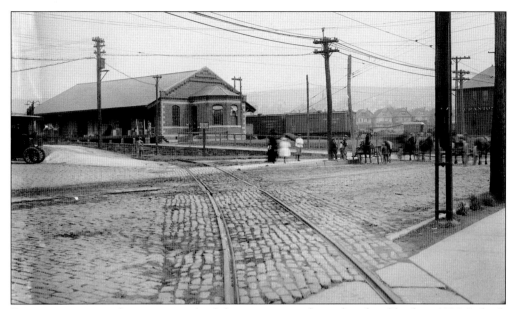

Scranton maintained a vast network of electric streetcar lines that dated back to 1886. Indeed, the city operated what is widely recognized as the first commercially operated electric streetcar system in the United States. In a few instances, streetcar lines intersected with tracks owned by the Lackawanna Railroad, such as this location on Cedar Avenue. This particular stretch of track was a connector that enabled the Lackawanna to interchange cars with the Lackawanna & Wyoming Valley Railroad. (Image C1162, Watson Bunnell.)

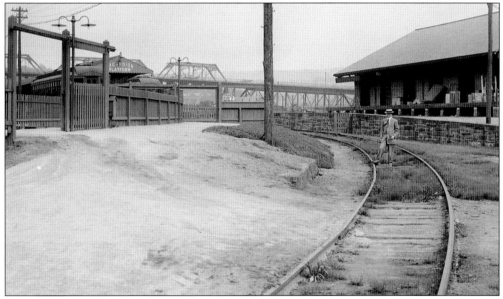

Slightly farther east of the site pictured in the previous image is the Scranton terminal of the Lackawanna & Wyoming Valley Railroad, commonly known as the "Laurel Line." The company's passenger station is to the left, just out of view, while the freight depot is on the right. A good deal of coal traffic was exchanged between both railroads at this point. While the passenger station would be razed in the 1960s, the freight depot is still used—in modified form—as a warehouse. (Image C1161, Watson Bunnell.)

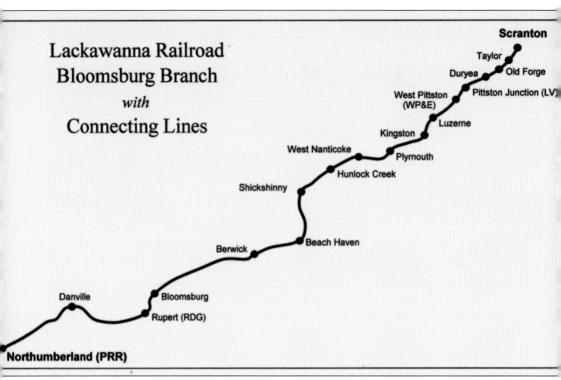

This map shows the length of the Bloomsburg branch as operated by Lackawanna Railroad beginning in 1873. The line begins at the west end of Scranton's City Yard and continues 80 miles in a southwest direction to the town of Northumberland. Each town along the route had a depot with its own unique character, and coal breakers dotted the line for most of its route. Most of the branch remains in service with the exception of an abandoned portion between Kingston and Berwick. (Author's collection.)

Six

THE BLOOMSBURG BRANCH

In 1873, the Lackawanna Railroad acquired control of the Lackawanna & Bloomsburg Railroad, a line completed in 1860 that ran between Scranton and Northumberland, Pennsylvania. Through this acquisition, the Lackawanna gained access to additional coalfields in the Wyoming Valley, a brisk passenger business, and a direct connection to the mighty Pennsylvania Railroad at Northumberland. The branch closely followed the north shore of Susquehanna River for much of its 80-mile route.

Through a haulage agreement, the New York, Ontario & Western Railway operated trains over the branch as well. These trains ran northbound from the Lehigh Valley Railroad's Coxton Yard in Pittston and Lackawanna's Keyser Valley branch, after which they would switch over to their own rails. Southbound trains used that company's own trackage to reach a connection with the Lehigh Valley north of Pittston Yard. This circular route existed until 1957, when the New York, Ontario & Western ceased operations.

The "Bloom," as it was commonly known, saw well over 100 years of continuous use through the subsequent Erie-Lackawanna merger and into the Conrail era. In the early 1980s, Conrail elected to abandon the line as a cost-cutting measure. Since the coal traffic and passenger business had long since disappeared, there was little motivation for Conrail to maintain the line.

The former Bloomsburg branch is currently operated by several different companies, while the section between Kingston and Berwick has been removed. Between Northumberland and Berwick, the line is operated by the North Shore Railroad. Trackage between Kingston and Pittston is owned by the Luzerne County Rail Authority. The Reading & Northern Railroad maintains the tracks between Pittston and Taylor, while Canadian Pacific controls the final few miles between Taylor and Scranton.

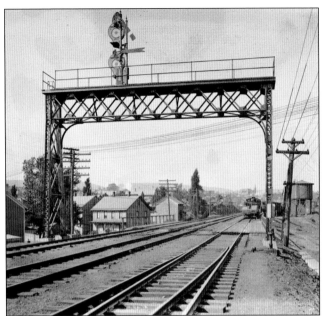

On September 24, 1913, a switcher works the south end of Hyde Park Yard in Scranton. Hyde Park Yard was located just south of the Lackawanna River Bridge on the west side of the river. It was used to accommodate coal traffic, for which there was no room within the confines of City Yard. Empty coal cars would be stored here, as well as loaded coal cars waiting to be picked up by trains headed east. The bridge in the foreground carries the railroad over Luzerne Street. This section of the Bloomsburg branch is still used daily by trains operated by the Canadian Pacific Railway. (Image B1628, Watson Bunnell.)

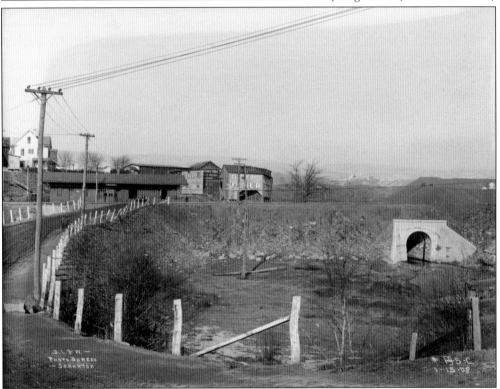

The wooden Taylor station, constructed in 1878, is pictured on January 15, 1908. Several months later, the Lackawanna would construct a new passenger depot opposite the original combination freight and passenger station, which would itself see continued use as a freight house. The view in this photograph taken from Depot Street looks west toward coal piles visible in the distance. (Image C145, Watson Bunnell.)

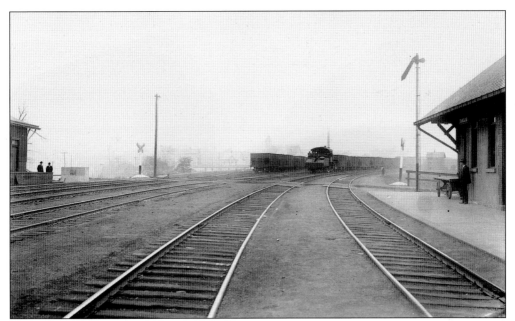

A switching crew works the south end of Taylor Yard on a foggy morning in May 1915. Taylor Yard was primarily used as a holding area for empty coal hoppers waiting to be sent to the mines for reloading. To the right of the photograph is the 1908-era passenger station, while the freight house, dating from 1878, is to the left. (Image C2628, Watson Bunnell.)

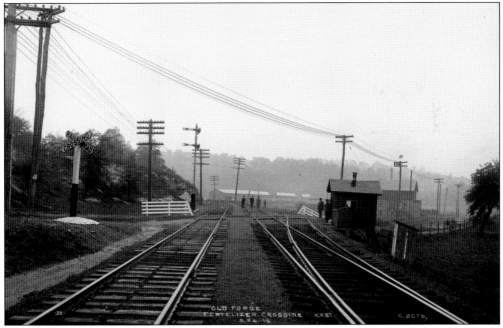

South of Taylor, the line cuts through the town of Moosic, Pennsylvania, although there was no depot located here due to the proximity of stations in Taylor and Old Forge. The railroad did, however, service the Lackawanna Fertilizer and Chemical Company, which is seen in the background of this May 1915 east-facing view. Today, this section of track is operated by the Reading & Northern Railroad. (Image C2629, Watson Bunnell.)

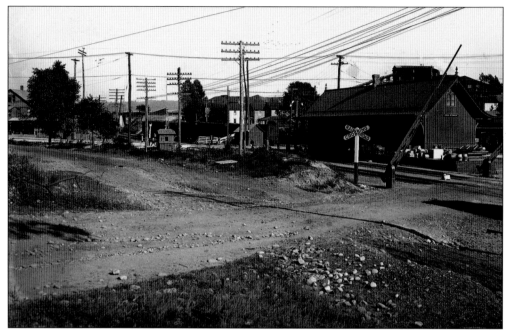

The borough of Old Forge, Pennsylvania, can trace its roots to the early 1800s as a stagecoach stop in the rural country between Scranton and Wilkes-Barre. The Lackawanna & Bloomsburg Railroad began serving the town in 1856. The wooden depot shown in this October 1914 image likely dated to the 1880s. (Image C2278, Watson Bunnell.)

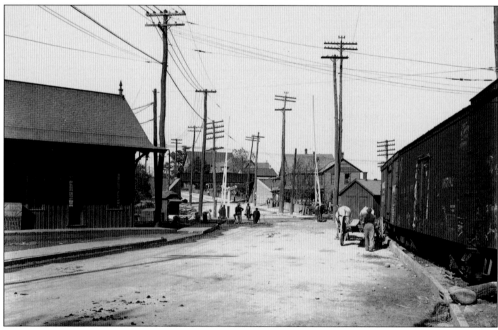

The Old Forge team track appears quite busy on October 2, 1914. Team tracks were built so that freight cars could be set off by a train and then unloaded by the customer. In this image, a team of workers unloads a shipment of lumber while other carloads of produce wait their turns. (Image 2277, Watson Bunnell.)

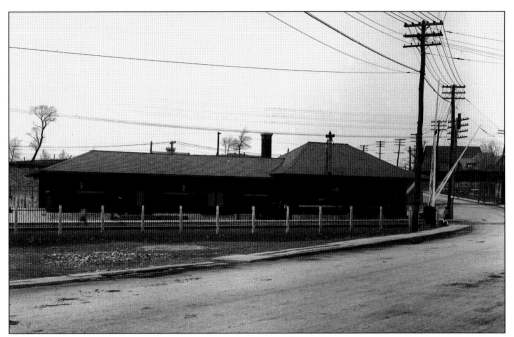

In 1915, the Lackawanna Railroad completed a new Old Forge depot to replace the antiquated original. This combination brick and concrete station survives today and is home to several businesses. The bridge visible behind the depot in this 1916 photograph carried a short branch over South Main Street to the nearby Jermyn branch of the Erie Railroad. (Image C3419, John Anneman.)

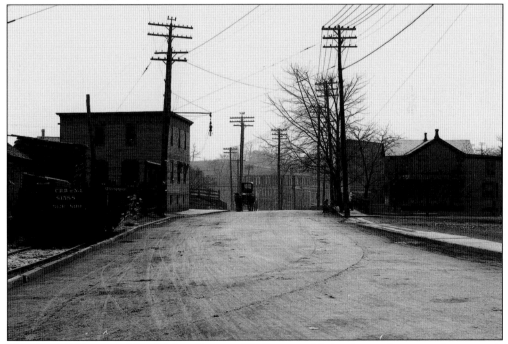

This April 1916 image of South Main Street in Old Forge was likely taken to document the approach to the grade crossing near the depot. What was simply a documentary photograph when taken is now a priceless image of a small town nearly 100 years ago. (Image C3420, John Anneman.)

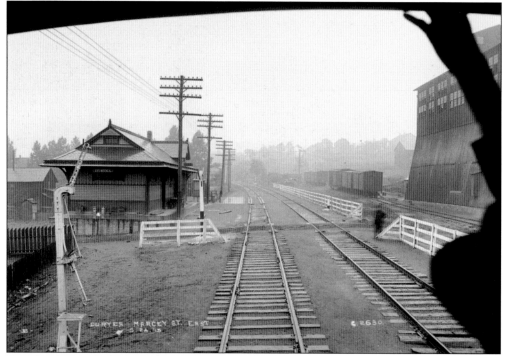

On May 24, 1915, photographer Bunnell captured the Duryea train station from the rear of a westbound train. The roofline of the passenger car is visible, as is an unidentified employee. Located on the right is the Lackawanna Railroad's Hallstead Breaker. (Image 2360, Watson Bunnell.)

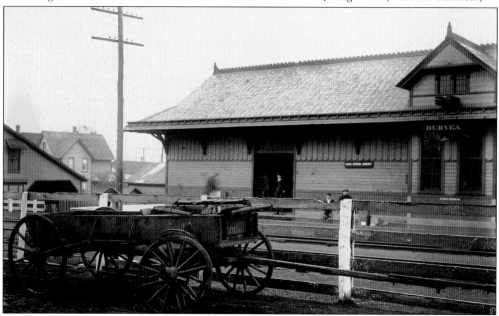

Watson Bunnell was again summoned to Duryea in October 1915 to document the results of a collision between a train and wagon at the nearby Marcy Street crossing. Again, a photograph that was taken to document a relatively minor incident now affords a fascinating look at the 1878-era depot, which was torn down sometime in the 1960s. (Image C3022, John Anneman.)

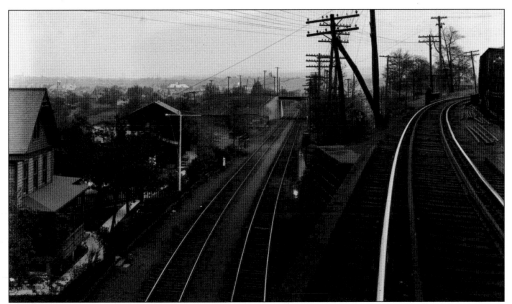

The Lackawanna Railroad's Bloomsburg branch is seen in May 1915 approaching Pittston from the north. The bridge in the foreground was a component of the Lehigh Valley Railroad's "Mountain Cutoff," a steep, circuitous route that allowed the company's through freights to avoid the traffic congestion in the nearby city of Wilkes-Barre. Both the Mountain Cutoff and this section of the Bloomsburg branch are today operated by the Reading & Northern Railroad. (Image C2529, Watson Bunnell.)

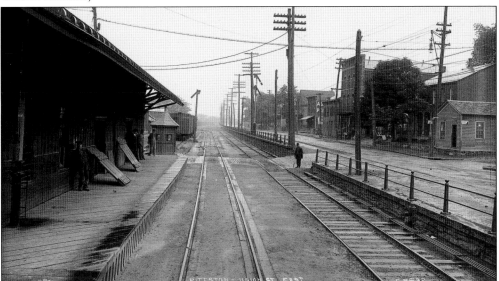

The station at Pittston Junction was constructed in 1888 and used by both the Lackawanna and Pennsylvania Railroads. The building was maintained as part of a cooperative agreement between the two railroads that closely paralleled each other along the Susquehanna River. The companies honored each other's tickets, allowing passengers a broader range of destinations by simply crossing the river on any number of bridges. The Lackawanna also offered sleeping car service to Pittsburgh, turning the cars over to Pennsylvania Railroad at Northumberland. (Image C2632, Watson Bunnell.)

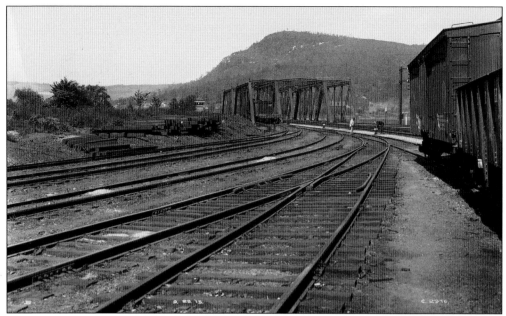

The interchange location between the Lehigh Valley and Lackawanna Railroads at Pittston Junction is pictured on September 29, 1915. The bridge in the background leads carries the Lehigh Valley to Coxton Yard, continuing northward to Sayre, Pennsylvania, and eventually Buffalo, New York. Today, the Reading & Northern connects with the Luzerne & Susquehanna Railroad at this location. (Image C2976, Watson Bunnell.)

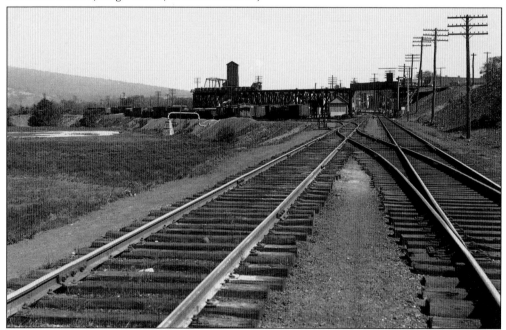

A narrow gauge mine train passes over the Bloomsburg branch on an elevated right-of-way in this September 1915 photograph. Below the trestle is a Lackawanna freight train interchanging cars with the Lehigh Valley Railroad. There are two sets of tracks at this location: the Bloomsburg branch to the left, and the Lehigh Valley on the right. (Image 2972, Watson Bunnell.)

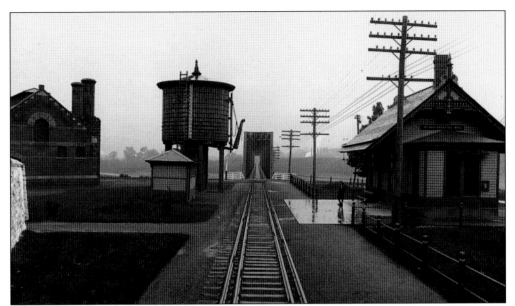

South of Pittston Junction, the Bloomsburg branch crossed the Susquehanna River and then entered the borough of West Pittston, passing the charming Susquehanna Avenue station along the way. To the extreme left of the image is a portion of the West Pittston & Exeter Railroad's right-of-way to Harding, Pennsylvania. The West Pittston & Exeter was one of the smallest short-line railroads in the nation, operating only three miles of track that originated at a junction a few hundred feet behind the photographer. (Image 2633, Watson Bunnell.)

West Pittston was the site of several industries, including the Hitchner Biscuit Company, which is visible in the background of this c. 1915 photograph. The company was a large producer of crackers and cookies and operated until 1951 as part of the National Biscuit Company (which became Nabisco in 1971). The building was recently converted into apartments, and its original exterior advertising has been restored. (Image C2133, John Anneman.)

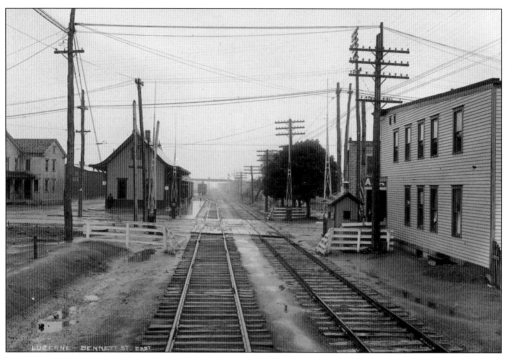

The Lackawanna Railroad's depot in the borough of Luzerne was located at Bennett Street, as seen here in May 1915. While the population of Luzerne never exceeded 8,000, the town was home to several coal mines, factories, and mills. The bridge in the distance connected with the nearby West Pittston branch of the Lehigh Valley Railroad to the company's main line on the opposite side of the Susquehanna River. (Image C2645, Watson Bunnell.)

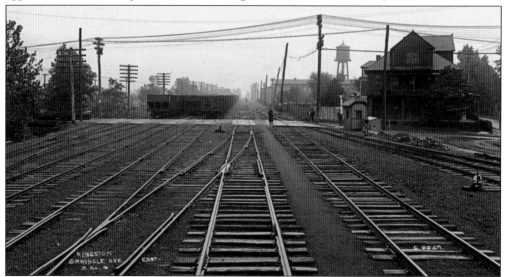

Kingston, Pennsylvania, was a major hub on the Bloomsburg branch. In addition to a roundhouse, Kingston was also the site of a large yard used to marshal coal cars traveling to and from several area mines. This image, as with several others from May 24, 1915, was taken from the rear of a train, as inclement weather precluded outdoor photography. The line is now abandoned from Kingston south to Berwick, having been dismantled in the early 1980s. (Image C2647, Watson Bunnell.)

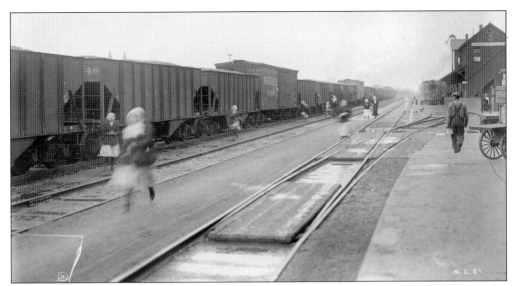

A common sight along coal-hauling railroads were the throngs of women and children who would retrieve pieces of coal that fell off moving trains. The scavenged coal was then used to heat homes or cook food. A group of coal pickers, as they were often called, is pictured near the Kingston station in this undated photograph. Dangerous and costly to the railroads, coal picking was officially forbidden yet remained a regular practice. (Image G27, Watson Bunnell.)

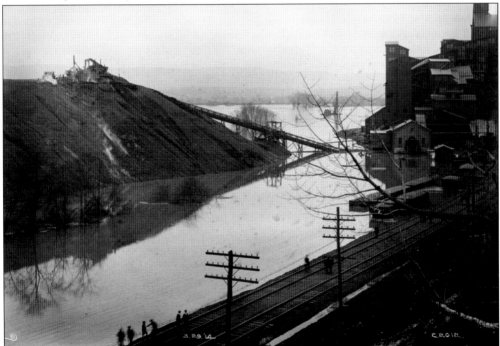

While the west bank of the Susquehanna River offered a natural path upon which to construct a railroad, it also had the ability to inflict damage and affect company operations. That destructive capability is illustrated in dramatic fashion by this image from March 29, 1914, showing the Lackawanna's Woodward Breaker inundated by floodwaters near Edwardsville. (Image 2012, Watson Bunnell.)

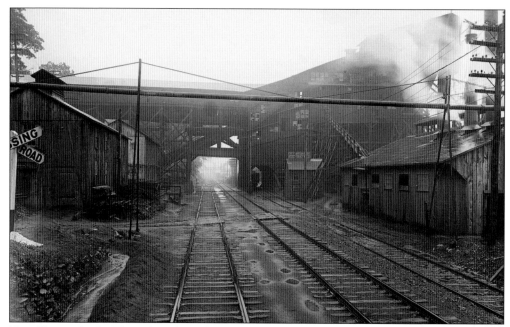

Near Plymouth, the Bloomsburg branch passed between buildings belonging to the Lackawanna's Avondale Breaker, as seen here in May 1915. The facility was located directly over the mine itself and was the site of one of the largest mining disasters in Pennsylvania. On September 6, 1869, the original breaker building burned, trapping and suffocating 108 miners in the shaft below. (Image 2648, Watson Bunnell.)

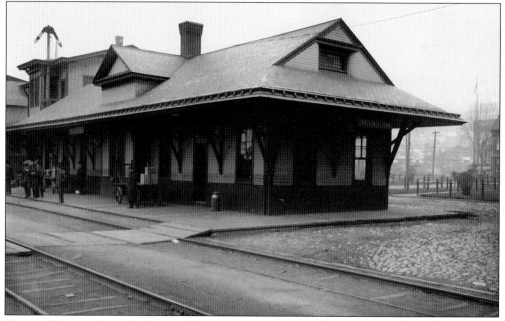

Plymouth, Pennsylvania, had a wood-frame station similar to others along the Bloomsburg branch and is pictured here in April 1916. There were a number of collieries in the area, as well as textile mills and other enterprises. During the years immediately prior to World War I, the population of Plymouth exceeded 10,000. (Image C3432, John Anneman.)

The advent of rail travel brought with it the ability to move products over long distances in a relatively short amount of time. In this October 1914 scene on Main Street in Plymouth, the West Lumber Company has received a carload of lumber from the Central of Georgia Railroad. (Image C2286, Watson Bunnell.)

The West Nanticoke station, pictured here in May 1915, is one of two depots to survive the dismantling of the Bloomsburg branch through this area and is now privately owned. The Pennsylvania Railroad crossed the Susquehanna River on a bridge located not far behind the photographer and connected with the Lackawanna Railroad here. The bridge visible in the background allows vehicular traffic to cross the river between West Nanticoke and Nanticoke. (Image 2649, Watson Bunnell.)

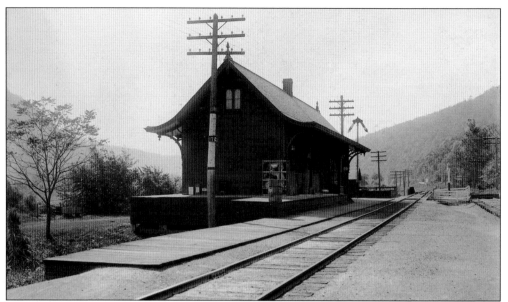

The second depot to escape demolition along the abandoned portion of the Bloomsburg branch is the 1873 station in Hunlock Creek. Across the street from the depot was a small amusement park called Croops Glen, which closed during World War II. At an unknown date, the station was turned perpendicular to its original location and set upon a cinder block foundation. It can still be spotted from nearby US Route 11 in derelict condition along the abandoned right-of-way. (Image C785, Watson Bunnell.)

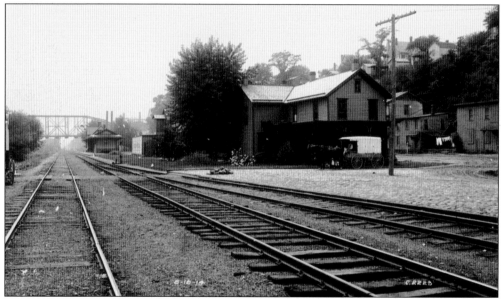

Berwick, Pennsylvania, provided a major source of revenue for the Bloomsburg branch, as freight cars constructed at the American Car and Foundry plant would be shipped to customers via the Lackawanna. The company's Berwick passenger station is seen in the distance in August 1914. Regrettably, that station did not survive the 1950s, yet a brick freight house situated behind the photographer is still standing. Today, the North Shore Railroad operates trains over this section of track. (Image C2223, Watson Bunnell.)

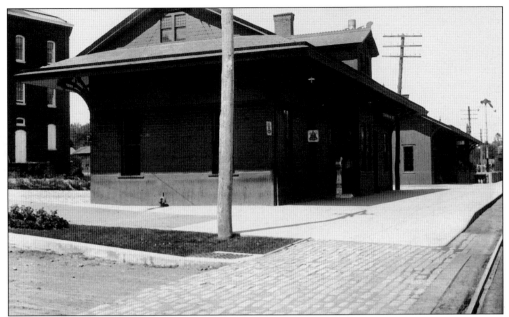

Like so many other depots along the line, the Bloomsburg station was a wooden structure erected in the 1880s. As seen here in June 1908, the passenger and freight depots are two separate buildings, but both no longer exist. The Lackawanna also maintained a small yard and turntable in town. Despite what its name might imply, the Bloomsburg branch did not end in its namesake town, but instead continued for some distance along the Susquehanna River. (Image C259, Watson Bunnell.)

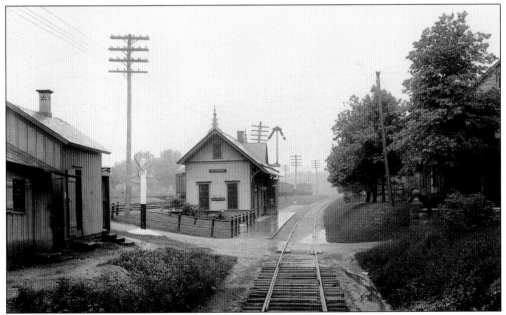

At Rupert, Pennsylvania, the Lackawanna Railroad was afforded the opportunity to interchange freight with the Reading Company. Cars on the Reading's Catawissa branch are visible behind the 1880 station. This is another classic scene captured by photographer Bunnell from the rear of a westbound train on a rainy May 24, 1915. (Image C2655, Watson Bunnell.)

A local landmark and three modes of transportation are visible in this June 1911 photograph of the Bloomsburg branch north of Danville, near Catawissa. The now defunct North branch of the Pennsylvania Canal is to the left of the railroad, while a primitive dirt road is to the right. Subsequent construction would see the road widened significantly, and the railroad shifted to the former canal path. Known as "hanging rock," the stone outcropping is still recognizable to motorists driving US Route 11. (Image C897, Watson Bunnell.)

In the days when railroad employees would commonly ride the roofs of freight cars, adjusting manual brakes, tunnels and overhead bridges presented a constant danger to the poor soul who might be caught off guard. As a safety measure, the railroads installed dangling ropes that would instantly let a worker know that he should duck and cover should he come in contact with them. This particular set of telltales was installed near the Reading Company's bridge over the Lackawanna at the station at Danville, Pennsylvania. (Image C2658, Watson Bunnell.)

The Lackawanna Railroad's station in Danville is pictured on June 8, 1917. The wooden depot was constructed by the Lackawanna & Bloomsburg Railroad in 1873, the same year the line was acquired by the Lackawanna Railroad. Above the photographer is the bridge that carried the Reading Company into downtown Danville. (Image C4090, Watson Bunnell.)

The last mile of the Bloomsburg branch more closely resembles a neighborhood trolley line than a busy railroad as it passes through Northumberland on October 4, 1909. Just beyond the curve in the distance is the end of Lackawanna territory and a junction with the giant Pennsylvania Railroad. (Image C522, Watson Bunnell.)

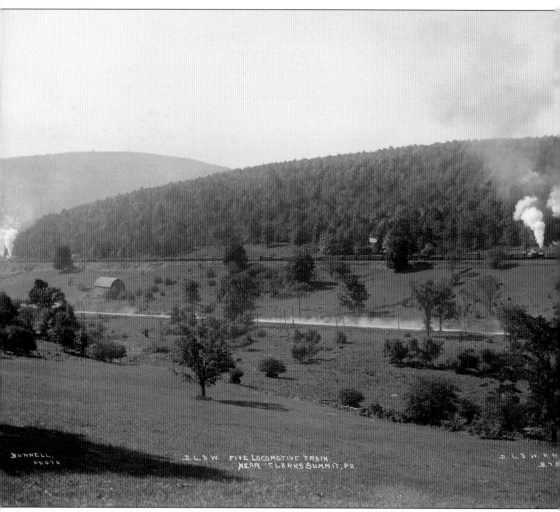

In a scene that demonstrates the effort required to move freight out of the Scranton area, five locomotives muscle some 50 cars upgrade near Clarks Summit, Pennsylvania, around 1910. Soon, the Lackawanna Railroad would begin a massive construction project in an effort reduce the brute force required to climb out of the valley. The ensuing few years will see a relocated right-of-way with new stations and awe-inspiring viaducts taking shape over the 39 miles between Clarks Summit and Hallstead. (Image B795, Watson Bunnell.)

Seven

WEST TO NEW YORK

The roughly 60-mile stretch of track between Scranton and Binghamton, New York, was among the earliest laid down by the Lackawanna Railroad, with operations dating to 1851. This same section of track would see some of the most extraordinary undertakings during the modernization of the Lackawanna.

Beginning some 8 miles west of Scranton near Clarks Summit and continuing 39 miles west, the Lackawanna would construct what was essentially a new railroad alongside the original right-of-way. The Clarks Summit–Hallstead Cutoff would feature reduced grades and sweeping curves, thereby increasing the speed that trains could travel. This also reduced the amount of fuel consumed by the locomotives powering those trains as well as wear and tear on equipment and track.

The new line would follow the hillsides instead of winding through the valleys below. This required massive amounts of fill in some places and deep cuts through solid rock in others. The centerpiece of the new rail line would prove to be two massive concrete viaducts over the Tunkhannock and Martins Creeks. The Tunkhannock Viaduct near Nicholson, Pennsylvania, remains the largest steel-reinforced concrete arch bridge in the world.

The line between Scranton and Binghamton, New York, remains the most active portion of the former Lackawanna Railroad. Becoming part of the Erie-Lackawanna in 1960 and Conrail in 1976, this section of railroad was purchased by the Delaware & Hudson Railroad in 1980. Today, the Delaware & Hudson is part of the Canadian Pacific Railway, which operates several trains each day over the line.

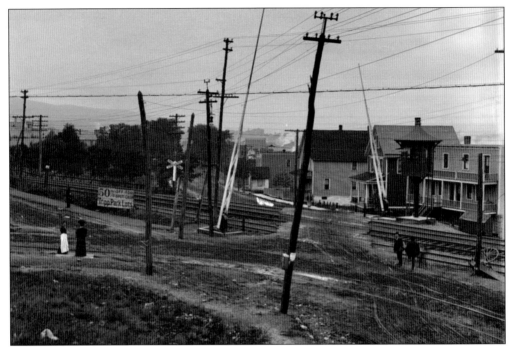

Just west of the Lackawanna Railroad's City Yard was a grade crossing at North Main Avenue in Scranton. This crossing was located on a curve and nearby embankments made for very limited-sight distances. Apparently on or shortly prior to September 19, 1909, a collision occurred at this site, as an overturned wagon is seen in the lower right-hand side of the image. (Image C105, Watson Bunnell.)

Always looking for ways to eliminate at grade crossings, in 1913 the Lackawanna Railroad completed an underpass at the same location as seen in the above photograph. Typical of smaller spans on the line, the bridge was constructed of steel and concrete. One hundred years later, the undercrossing has stood the test of time and still bears the weight of several trains each day. (Image B1548, Watson Bunnell.)

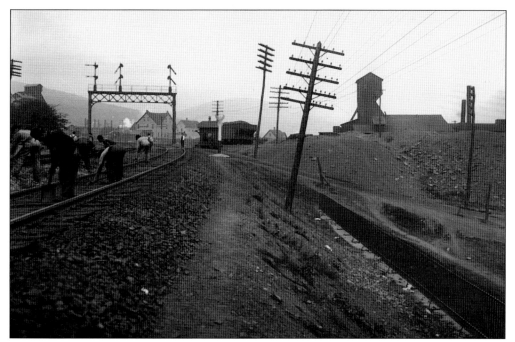

A work gang spreads ballast over railroad ties in October 1914 as a watchman keeps a sharp eye out for approaching trains near the semaphore signals in the background. The location is a primitive crossing at Theodore Street in Scranton, which would later be replaced by means of an undercrossing similar to that at North Main Avenue. The Lackawanna's Cayuga Breaker is seen in the distance. (Image C2301, Watson Bunnell.)

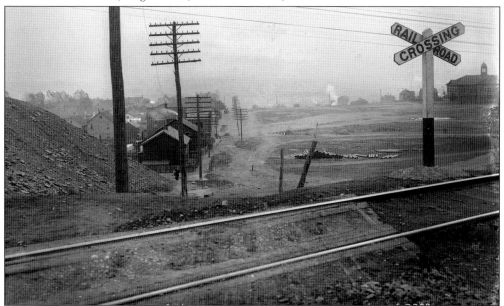

This view looking to the east from the crossing at Theodore Street provides an expansive scene of Scranton's Providence neighborhood with Public School No. 40 visible in the distance. This school would be replaced by the North Scranton High School in 1922. (Image C2299, Watson Bunnell.)

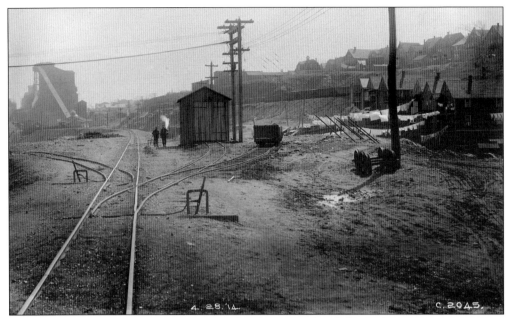

The Cayuga Breaker was adjacent to the right-of-way as it headed west from Scranton. In 1914, the year of this photograph, the breaker processed over 200,000 tons of coal and employed over 700 men. In the foreground are narrow gauge tracks used by diminutive locomotives to shuttle coal cars about the complex. The Lackawanna main line is visible beyond the houses to the right. (Image C2045, Watson Bunnell.)

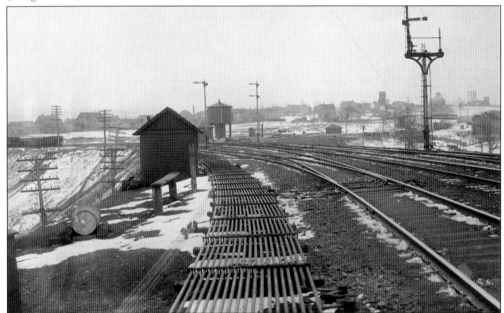

The Lackawanna Railroad's Keyser Valley branch met with the main line in North Scranton at a location known as Cayuga Junction. In this undated photograph, the Keyser Valley branch is seen diverging to the right, as the view faces east toward Scranton. In the foreground are the mechanical rods that linked the individual switches with the positioning levers in an interlocking tower, just behind the photographer. (Image G6, Watson Bunnell.)

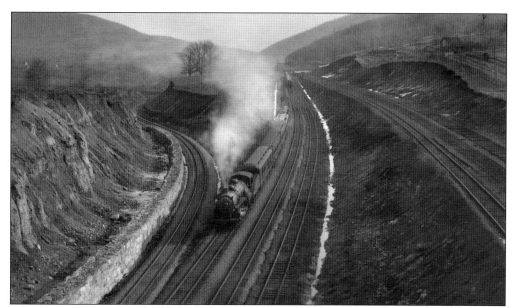

A passenger train speeds away from Scranton in this January 1916 image that illustrates the actual starting point of the Clarks Summit-to-Hallstead Cutoff. The right-hand side embankment is the original main line grade and connects to the new line in the distance. (Image B2316, Watson Bunnell.)

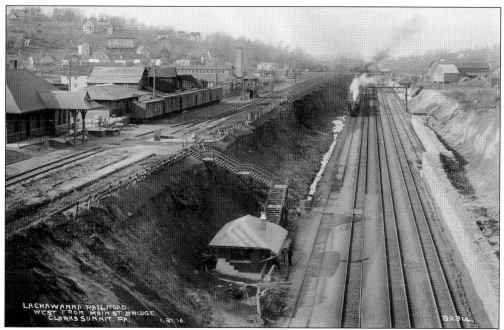

Building the first section of the cutoff resulted in a massive trench being dug through the town of Clarks Summit. The new main line is not even a year old in this January 1916 photograph. In this view looking west from the overhead bridge at Main Street, the original 1903 Clarks Summit has been spared from demolition with the addition of a waiting area at trackside below. Even with the discontinuance of passenger service decades later, the depot remains today and is used for office space. (Image B2314, Watson Bunnell.)

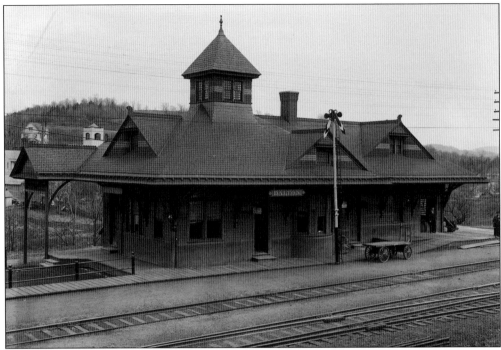

Three miles west of Clarks Summit was the town of Dalton, Pennsylvania. Like many depots along the original right-of-way, the Dalton Station was a wooden building of moderate size with decorative trim. This photograph, although undated, was likely taken in 1907. (Image B73, Watson Bunnell.)

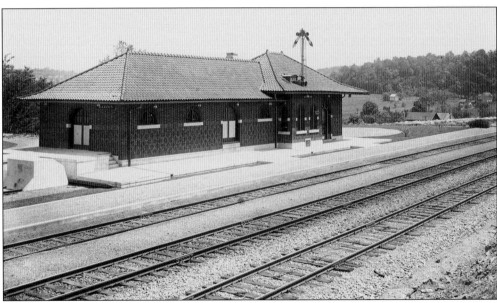

This 1916 photograph shows the new Dalton station shortly after construction was completed the year before. The depot is built primarily of brick and concrete, as was the common building practice at the time. It should be mentioned that there was no true standard Lackawanna station. Although many bore similarities to each other, each had its own individual character. (Image B2382, Watson Bunnell.)

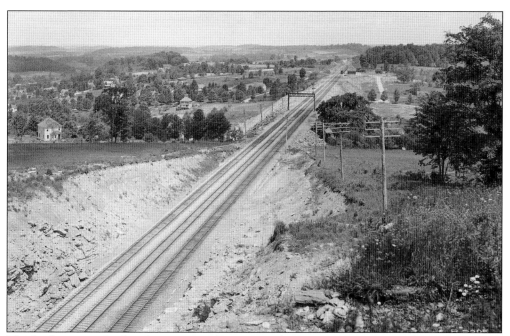

The Lackawanna Railroad's new main line was truly an engineering marvel, as seen in 1916 from a hillside overlooking Dalton, Pennsylvania. As this image illustrates, cuts through solid rock and massive amounts of fill were used to construct a straight and level right-of-way. The improvements brought to the Lackawanna Railroad led to its being considered the most highly developed railroad in the nation. (Image B2395, Watson Bunnell.)

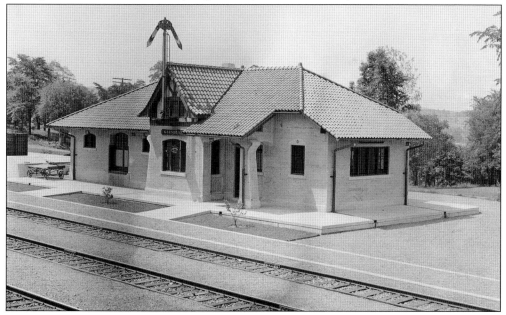

The depot along the new main line in Glenburn featured all-concrete construction, a relatively new practice at the time. The station, like others on the cutoff, was completed in 1915. Luckily, this depot survived the end of passenger service on the Lackawanna and is now a civic center. (Image B2390, Watson Bunnell.)

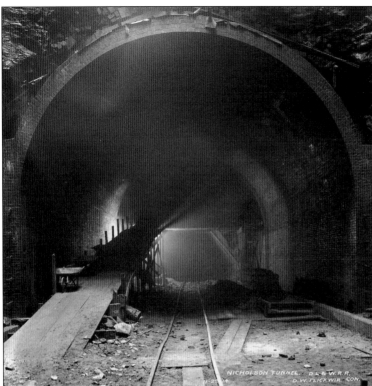

This November 1914 photograph shows construction work inside the Nicholson tunnel at one of two massive air vents. When completed, this would be the longest tunnel on the Lackawanna at 3,629 feet. It was also the only tunnel on the Clarks Summit–Hallstead Cutoff and the only Lackawanna tunnel to be lined with brick. (Image B2034, Watson Bunnell.)

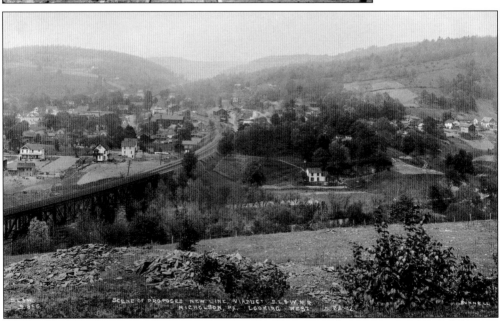

This May 1912 photograph of Nicholson, Pennsylvania, was taken in anticipation of the new line construction through the valley. In the lower left, a steel trestle carries the railroad across Tunkhannock Creek into town. The following months would see the company begin work on what many consider the Lackawanna Railroad's greatest accomplishment: the Tunkhannock Creek Viaduct. (Image B856, Watson Bunnell.)

The town of Nicholson is seen from a nearby hillside in 1912. To the lower right of the image is a small turntable adjacent to a lumber mill. Construction activity has begun on the Tunkhannock Viaduct, as evidenced by the short spur being installed on the left. (Image B2248, Watson Bunnell.)

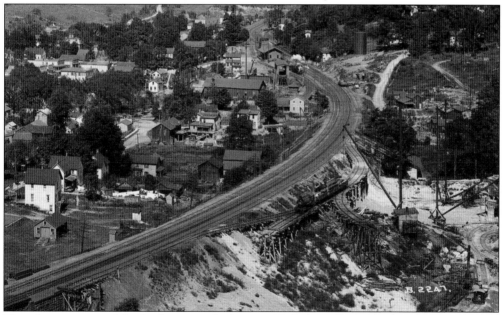

This close-up view of the Lackawanna facilities in Nicholson illustrates the winding path the right-of-way took through town. In the background is the original wooden station and interlocking tower with two steam locomotives at the ready. In the lower right, construction materials are being delivered to the future viaduct worksite. Today, US Route 11 passes by this wooden depot, which escaped demolition after the old main line was dismantled. (Image B2247, Watson Bunnell.)

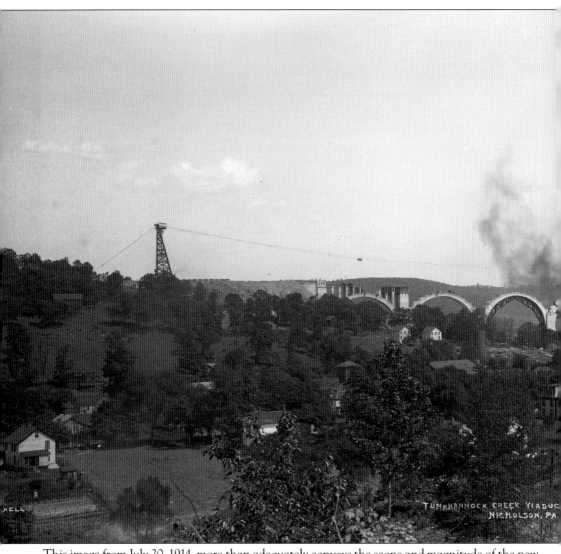

This image from July 20, 1914, more than adequately conveys the scope and magnitude of the new Tunkhannock Creek Viaduct in Nicholson, Pennsylvania. From start to finish, the bridge took three and a half years to complete. Its construction required 167,000 cubic yards of concrete and

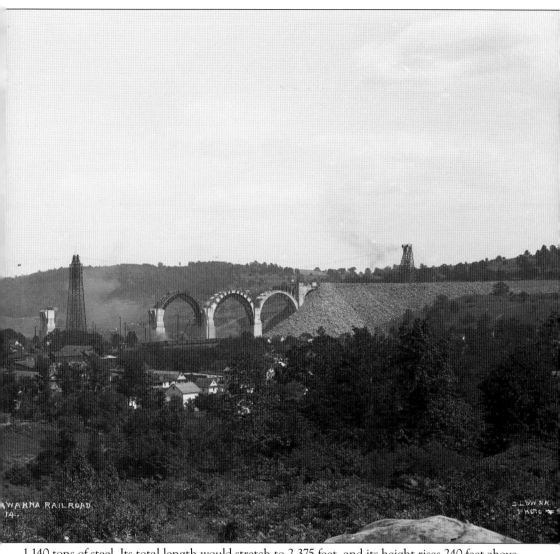

1,140 tons of steel. Its total length would stretch to 2,375 feet, and its height rises 240 feet above the creek bed below. This large-format photograph was taken using a 22-inch-long plate-glass negative. (Image L11, Watson Bunnell.)

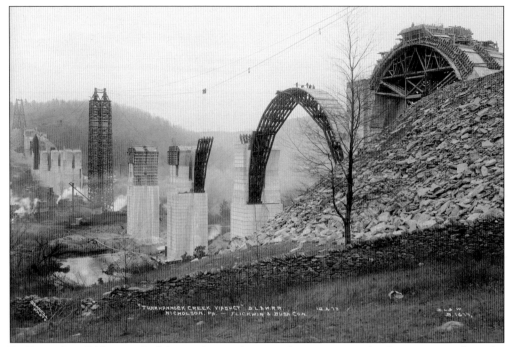

By December 1913, several of the viaduct arches were beginning to take shape, as seen from the northwest embankment. Each span continues 60 feet below ground level, reaching solid bedrock. The large tower in the background was part of a cable system used to deliver material to each work area. (Image B1677, Watson Bunnell.)

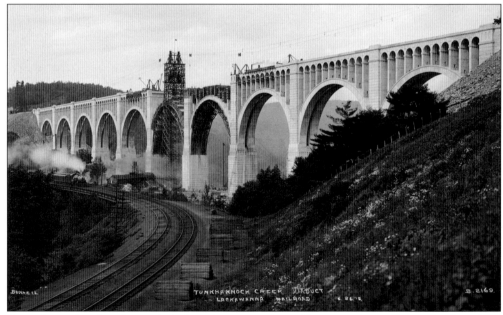

Several months of work remain before the new viaduct will carry train traffic, as this June 1915 image illustrates. Local urban legends of workers meeting their fates by falling into the concrete persist; however, the steel reinforcement design evident here makes those tales somewhat implausible. (Image B2169, Watson Bunnell.)

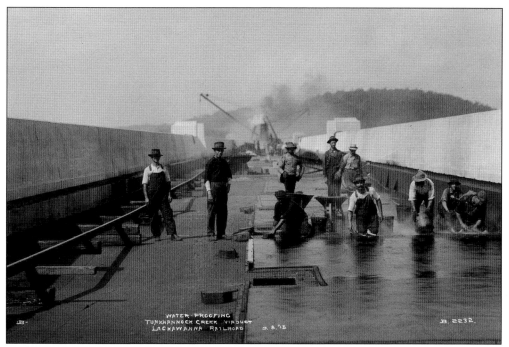

In this September 1915 photograph, workmen are busy sealing the bridge surface with tar. Stone ballast several feet high will cover this area in a matter of days as construction nears its end. Note the undulating surface of the bridge deck, so designed to funnel rainwater toward the square drains in the center. (Image 2232, Watson Bunnell.)

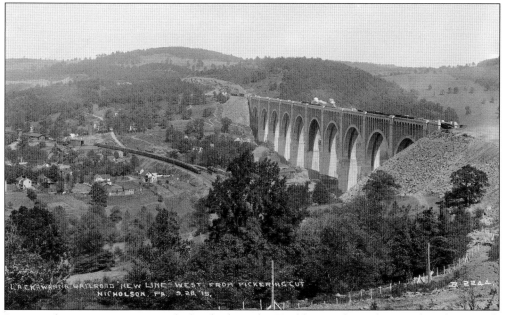

Large-scale construction is nearly finished on the Tunkhannock Viaduct in this photograph taken on September 28, 1915. Trains are still using the old main through the valley below, but track has reached the opposite end of the viaduct, with the new Nicholson station visible above the treetops. (Image B2244, Watson Bunnell.)

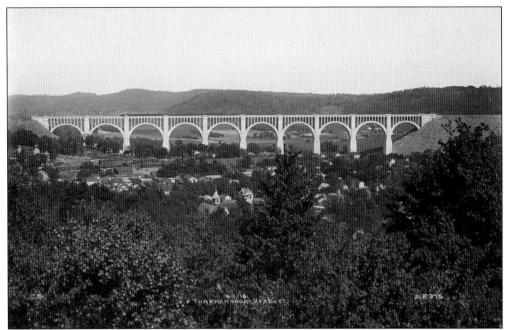

A passenger train crosses the Tunkhannock Viaduct on June 1, 1916. Construction of the bridge forever changed the look of the valley, in which the town of Nicholson was built. Residents have long embraced the bridge as the town symbol and host a commemorative festival each year on the second weekend of September. (Image B2375, Watson Bunnell.)

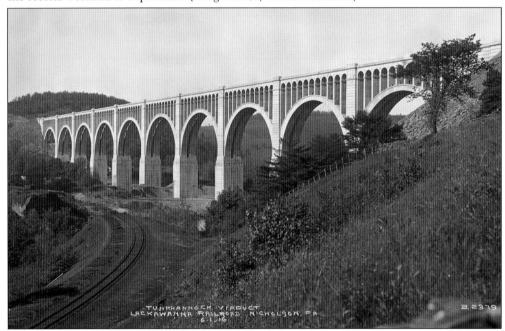

A closer look at the bridge in June 1916 reveals that the dismantling of the original main line is well underway. The large steel trestle pictured earlier has been removed, and soon, the rails will be gone too. Today, US Route 11 follows much of the original Lackawanna grade between Clarks Summit and Hallstead. (Image B2379, Watson Bunnell.)

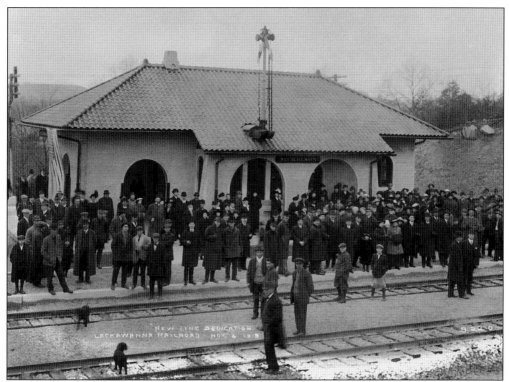

The Nicholson station saw a flurry of activity on November 6, 1915. This was the dedication day for the new station as well as the entire cutoff. It would appear that most of the town turned out for the event; even a few neighborhood dogs became part of the spectacle. Regrettably, this station was razed in the 1980s. (Image B2270, Watson Bunnell.)

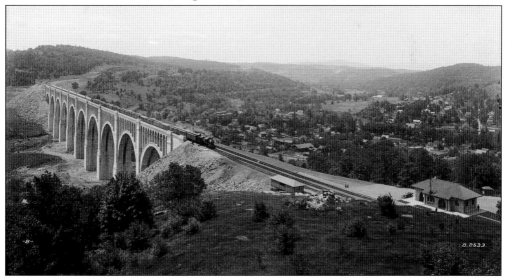

In this c. 1916 photograph, a Lackawanna milk train approaches the Nicholson station from the east. Note that the turntable in the town below has already been removed and was probably reinstalled somewhere else. The small shed in the foreground would have housed inspection cars and other equipment used to maintain the railroad. (Image 2533, Watson Bunnell.)

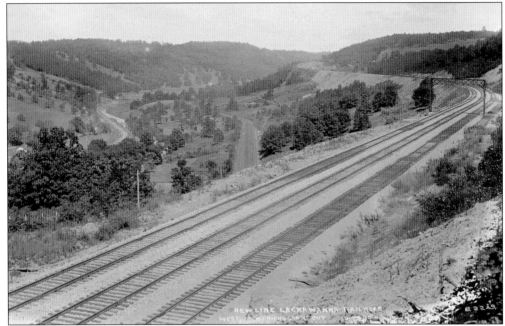

The Clarks Summit–Hallstead Cutoff had yet to open when this photograph was taken on September 25, 1915. Visible also is the original right-of-way, still in use through the valley below. In constructing the cutoff, the railroad would eliminate 2,400 degrees of curvature over the 39-mile route, or approximately six and one half full circles of track. (Image B2249, Watson Bunnell.)

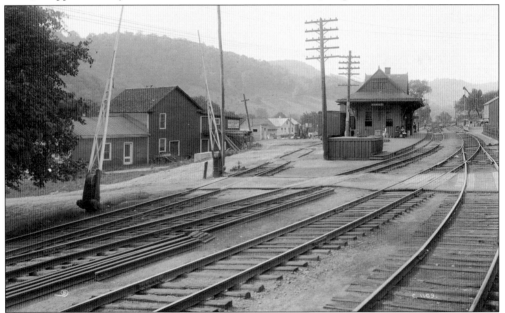

Returning to the original right-of-way, the town of Foster is pictured here around 1910. The wooden depot, similar in construction to so many others on the original main, was erected in 1888. Upon the opening of the cutoff, several sections of the old route were kept in place afterward to service freight customers. Several stations, like this one, continued to see use as freight-only stations before finally being torn down. (Image C1169, Watson Bunnell.)

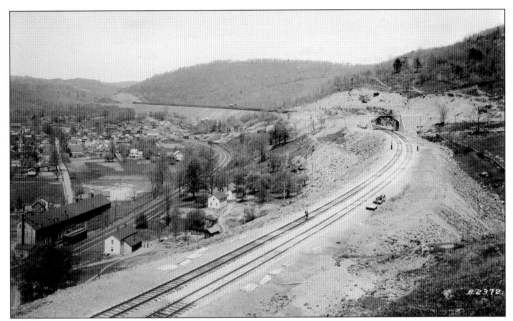

A sweeping curve carried the cutoff high above the town of Foster, as seen in this May 1916 image. These curves were almost always less than two degrees in curvature, allowing trains to operate at speeds exceeding 70 miles per hour. Many of the curves on the old route forced trains to slow to 40 miles per hour or less. Also of note here is a milk car spotted at a dairy located along the original route. (Image B2372, Watson Bunnell.)

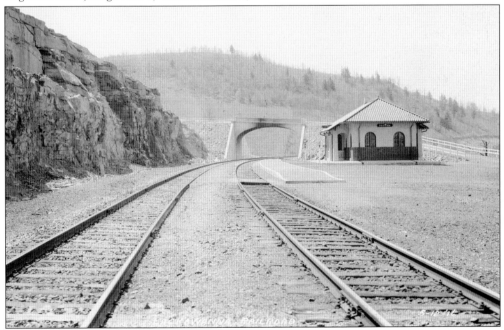

The new passenger station at Foster is pictured here in May 1916. The town of Foster had already been incorporated as the Borough of Hop Bottom, yet the railroad continued to use the traditional name. The brick and concrete station would last until 1991 before succumbing to the wrecking ball. (Image B2369, John Anneman.)

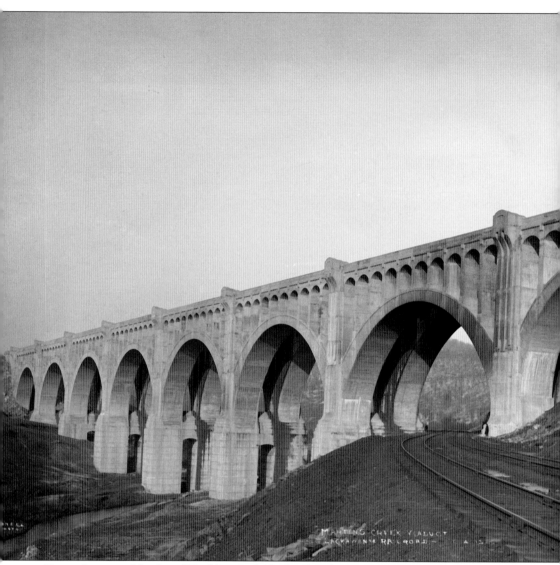

Five miles west of the famed Tunkhannock Viaduct lies the Martins Creek Viaduct, near Kingsley, Pennsylvania. Although somewhat smaller than the Nicholson structure, at 1,600 feet in length and over 200 feet tall at its highest point, the similarly constructed concrete span is impressive

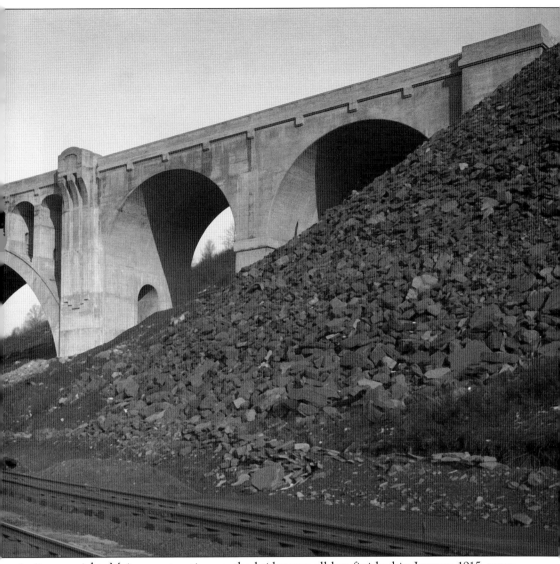

in its own right. Major construction on the bridge was all but finished in January 1915, some 10 months ahead of schedule. The original right-of-way under the bridge is now US Route 11. (Image L17, Watson Bunnell.)

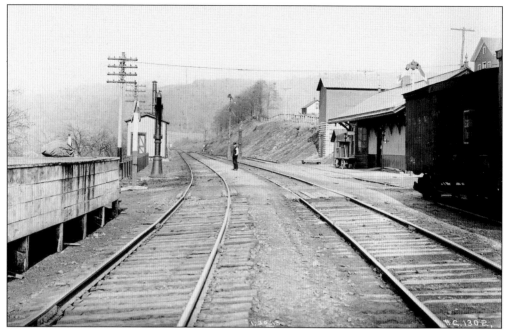

Kingsley, Pennsylvania, was the closest town to the Martins Creek Viaduct. The tiny hamlet was named for Rufus Kingsley, an early resident, upon the 1888 completion of the station. Beyond the boxcars to the right is the station that served the community, which was home to less than 100 people at the time. (Image C1302, Watson Bunnell.)

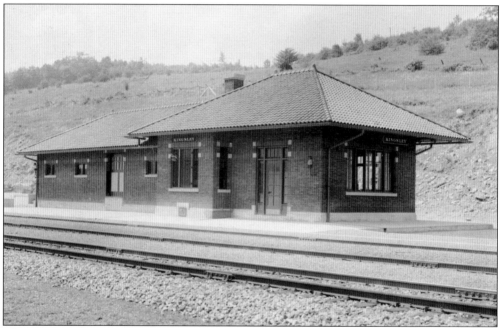

The new Kingsley station was constructed in 1915, like most others on the cutoff. The brick depot was the destination for Steamtown National Historic Site excursions in the early 1990s but was never owned by the National Park Service. The building was finally demolished in 2007, having fallen into disrepair and partially collapsing the year before. (Image 2399, Watson Bunnell.)

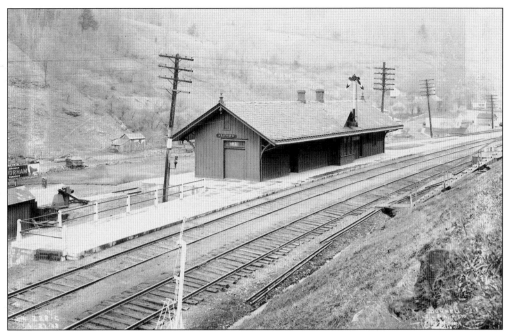

The original 1888 Alford, Pennsylvania, station was among the most simple on the line and is pictured here on April 27, 1908. In the foreground is a mechanism known as a mail crane, which allowed bags of mail to be picked up by railroad post office cars without stopping the train at each small town station. (Image C228, Watson Bunnell.)

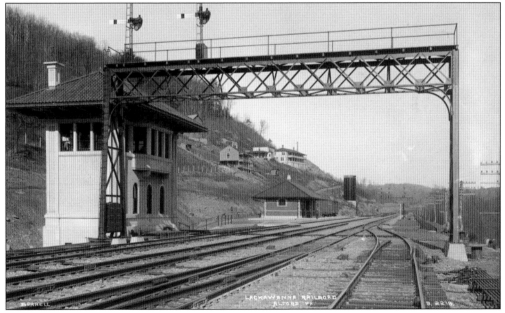

The replacement 1915 depot along the cutoff was also a simple affair. To the left is one of many concrete interlocking towers built by the Lackawanna. Both buildings still exist, although in derelict condition. The track on the right seemingly leading to nowhere was known as a split-rail derail and directed any runaway cars onto the siding away from the primary tracks so they would not run afoul of the main line. (Image 2278, Watson Bunnell.)

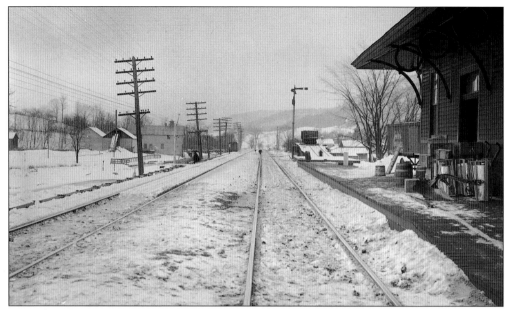

Even though it was called the Clarks Summit–Hallstead Cutoff, the new grade rejoined the original grade through the town of New Milford, Pennsylvania, several miles south of Hallstead. Therefore, the original 1893 passenger station, pictured in February 1910, would remain in service after the 1915 opening of the cutoff. The building survived until 1980, when it burned to the ground. (Image C581, Watson Bunnell.)

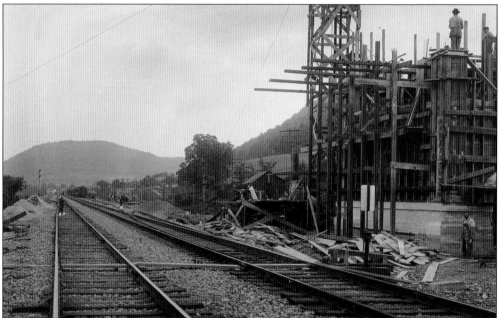

While the Lackawanna trackage in Hallstead did not undergo a substantial relocation during the modernization program, improvements were made along this portion of the line. This August 1915 photograph shows the new concrete interlocking tower near Hallstead while under construction. The boards placed between the rails allowed workers to cross their wheelbarrows over the tracks unimpeded. (Image C2897, John Anneman.)

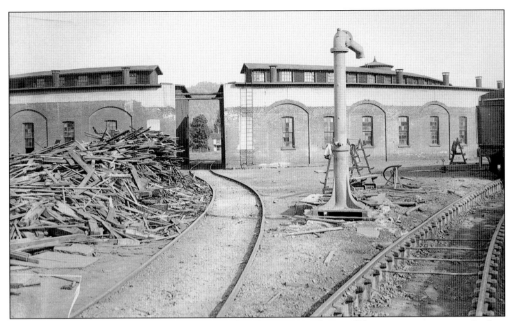

In addition to a station, the Lackawanna Railroad maintained a small locomotive servicing facility and roundhouse in Hallstead, which is pictured here in July 1912 after some apparent alterations. The Hallstead roundhouse was seldom photographed and rendered obsolete prior to 1920 when the Lackawanna built a much larger engine house in East Binghamton, New York, several miles to the west. (Image G31, Watson Bunnell.)

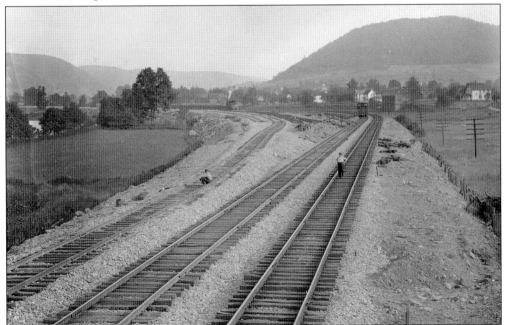

Located on the banks of the Susquehanna River, Hallstead, Pennsylvania, was the last town along the main line before the Lackawanna crossed into New York State. In 1915, the company built a sizeable yard that was constructed atop several feet of fill, raising it above the flood-prone river. (Image C2899, John Anneman.)

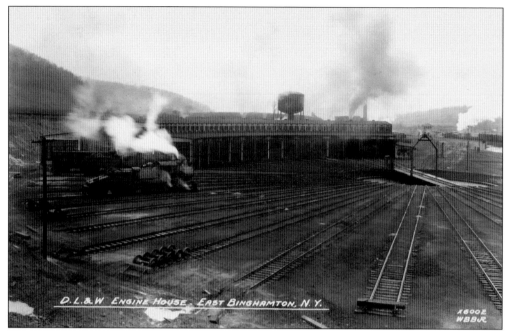

The Lackawanna's roundhouse in East Binghamton, New York, is pictured here in the late 1920s. The large number of open-air tracks radiating from the turntable would seem to indicate that little heavy repair work was performed at this location. This facility replaced the aging engine house in Hallstead around 1920. (Image X6002, William B. Barry.)

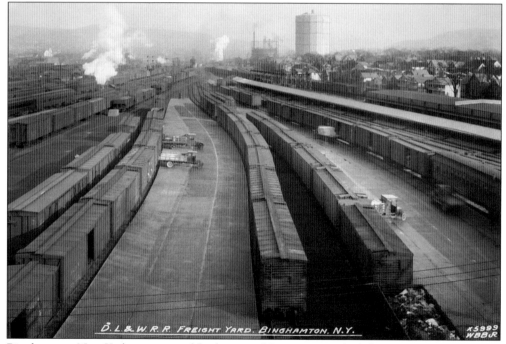

Binghamton, New York, a city roughly the size of Scranton, marked the westernmost point on the Scranton Division. Pictured here in the late 1920s is the city's sprawling freight yard with unloading platforms in the foreground. (Image X5999, William B. Barry.)

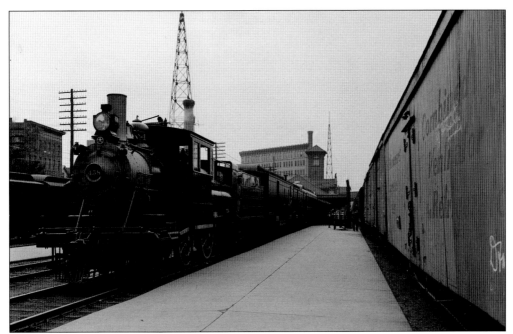

The Lackawanna Railroad's Binghamton passenger station was constructed in 1900. In this c. 1913 photograph, a passenger train is ready to depart the brick station. Behind the locomotive is a radio tower, erected by the Marconi Radio Company in 1913 as an experiment in communications with moving trains by radio. (Image C1550, Watson Bunnell.)

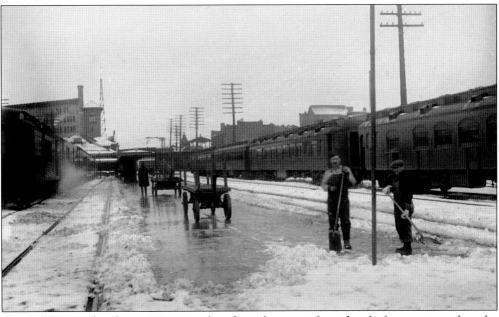

On a cold December day in 1914, several workers clear snow from the platforms surrounding the Binghamton station. The ornate brick depot almost met its end through the scourge of urban renewal in 1963, when plans were announced to demolish the building. The story has a happy ending though, as the station was spared and has been restored while in private ownership. (Image C2407, John Anneman.)

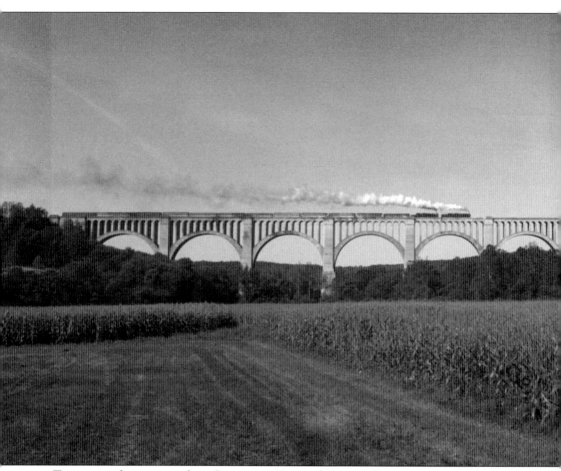
Two vintage locomotives from Steamtown National Historic Site power a rare public excursion across the Tunkhannock Viaduct in a scene reminiscent of railroading's glory years. The viaduct is perhaps the most enduring symbol of the Lackawanna Railroad, as it has been in continuous use since its opening in 1915. Today, freight trains operated by the Canadian Pacific Railway and Norfolk Southern Railroad pass over the span several times each day. (Author.)

Eight
THE LACKAWANNA RAILROAD TODAY

While the corporate history of the Delaware, Lackawanna, & Western Railroad may have ended upon its 1960 merger with longtime rival Erie Railroad, significant pieces of the "Road of Anthracite" remain in operation today.

From the Delaware Water Gap to Scranton, freight trains still rumble through the Pocono Mountains on a route that was nearly dismantled in the 1980s. In gradual increments, the former Lackawanna main line east of Scranton has been acquired by the various counties through which it passes. Since 1993, the Delaware–Lackawanna Railroad has been operating trains over this line as the contract operator, restoring track and growing a freight business that had all but disappeared by the time the railroad began operating.

On the Clarks Summit–Hallstead Cutoff west of Scranton, the rails have never been silenced. The Erie Lackawanna Railway assumed operation in 1960, abandoning service on much of the former Lackawanna west of Binghamton, New York. Operation between Scranton and Binghamton continued through the Conrail takeover of 1976. In 1980, the line was purchased by the Delaware & Hudson Railway in order to shift traffic off of its own original route due to the heavy grades present there. Canadian Pacific took control of the Delaware & Hudson in 1991 and continues to operate its own trains, as well as those of the Norfolk Southern Railroad, over the massive concrete viaducts for which the line is most remembered.

On portions of the Bangor and Portland branch, trains from the Norfolk Southern provide service to the Martins Creek coal-fired power plant as well as several other customers. Between Northumberland and Berwick, Pennsylvania, the North Shore Railroad provides service over the former Bloomsburg branch as does the Reading & Northern Railroad between Pittston Junction and Taylor Yard.

Several icons of the Lackawanna Railroad have been preserved for future generations to experience. In Scranton, the grand passenger station has been remodeled as a luxury hotel. Much of the former City Yard is now home to Steamtown National Historic Site, whose museum complex is centered in and around portions of the original roundhouse there. Restored steam and diesel locomotives are frequently used to power excursion trains to a variety of northeastern Pennsylvania destinations during the more popular months of the year.

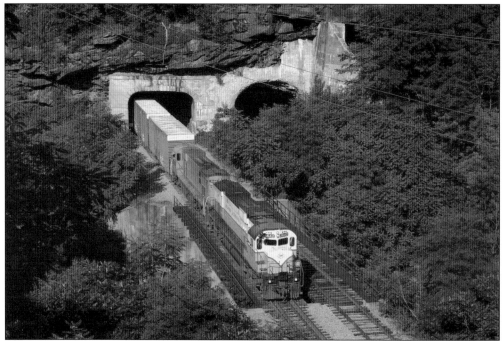

Delaware–Lackawanna Railroad engine 3642 exits the Nay Aug Tunnel in Scranton. This portion of the former Lackawanna Railroad is owned by the Pennsylvania Northeast Regional Railroad Authority and has been operated by the Delaware–Lackawanna Railroad since 1993. (Author.)

A Canadian Pacific Railway unit grain train is seen at Bridge 60 in Scranton, led by an original Delaware & Hudson locomotive. Since purchasing the Delaware & Hudson in 1991, Canadian Pacific has been operating the former Lackawanna Railroad between Taylor, Pennsylvania, and Binghamton, New York. (Author.)

A large section of the former Lackawanna Railroad Bloomsburg branch is operated today by the North Shore Railroad between Northumberland and Berwick, Pennsylvania. The railroad operates a number of locomotives painted similar to former Lackawanna units, such as engine 1946 seen on display in Scranton. (Author.)

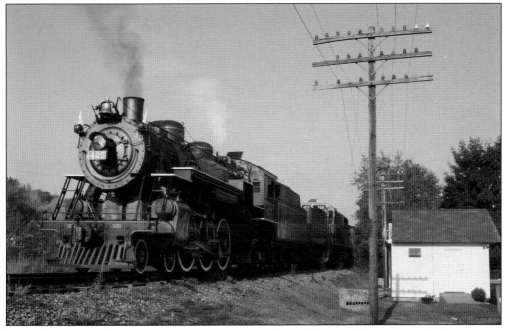

A Reading & Northern steam excursion prepares to depart Pittston, Pennsylvania. The company operates the former Bloomsburg branch between Pittston Junction and Taylor Yard, as well as industrial trackage that was once part of the Lackawanna Railroad's Keyser Valley Shops. (Author.)

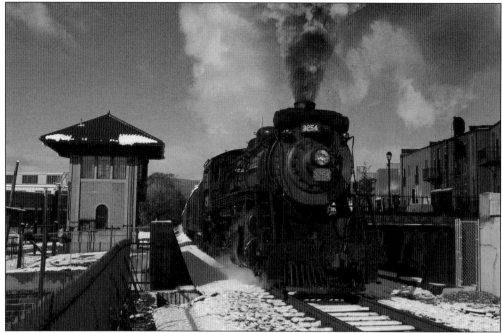

Former Canadian National steam locomotive 3254 departs Scranton with a Steamtown National Historic Site excursion. Since 1989, Steamtown has operated a variety of excursion trains over the former Lackawanna lines both east and west of Scranton. (Author.)

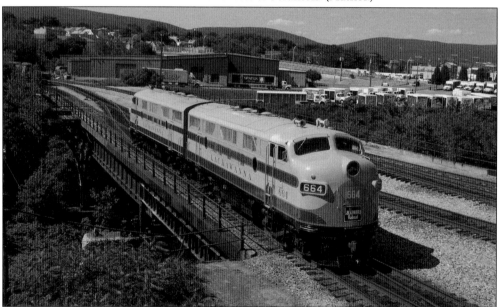

Unfortunately, very few Lackawanna Railroad locomotives were saved from the scrapper's torch. In 2010, the Anthracite Railway Historical Society and the Tri-State Chapter of the National Railway Historical Society combined forces to recreate a pair of classic streamliner-era Lackawanna Railroad locomotives. Taking two former Bangor & Aroostook Railroad units and altering their appearance has resulted in this set of otherwise extinct diesel power, pictured on the former Lackawanna at Bridge 60. (Author.)

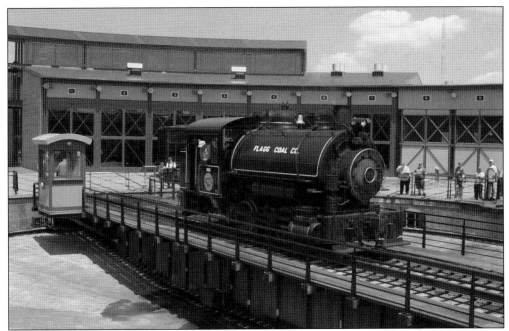

Several buildings in the former Lackawanna Scranton City Yard have been rehabilitated for use by Steamtown National Historic Site. Here, a locomotive built in nearby Wilkes-Barre, now privately owned, makes a special appearance in Scranton. A portion of the restored 1902 roundhouse is visible in the background. (Author.)

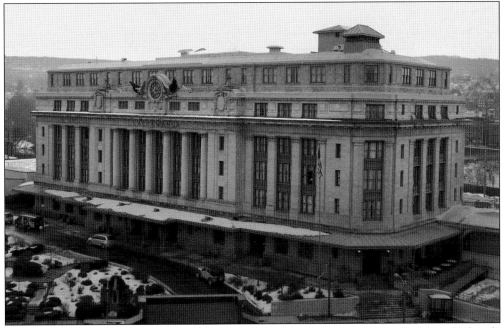

The 1908 passenger station in Scranton was erected as a monument to the Lackawanna Railroad's greatness. Over 100 years later, the building still conveys the same level of grandeur and elegance. Converted into a hotel in 1983, the station has been restored and is maintained in better-than-new condition. (Author.)

DISCOVER THOUSANDS OF LOCAL HISTORY BOOKS FEATURING MILLIONS OF VINTAGE IMAGES

Arcadia Publishing, the leading local history publisher in the United States, is committed to making history accessible and meaningful through publishing books that celebrate and preserve the heritage of America's people and places.

Find more books like this at
www.arcadiapublishing.com

Search for your hometown history, your old stomping grounds, and even your favorite sports team.

Consistent with our mission to preserve history on a local level, this book was printed in South Carolina on American-made paper and manufactured entirely in the United States. Products carrying the accredited Forest Stewardship Council (FSC) label are printed on 100 percent FSC-certified paper.